LENS and SHUTTER

LENS and SHUTTER

an introduction to photography

by

Harvey Weiss

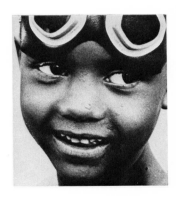

Young Scott Books

Table of Contents

PART III THE DARKROOM 105

The author is particularly indebted to the following photographers whose work is reproduced on these pages: ANSEL ADAMS, PETER BARLOW, GEORGE CARDOZO, HENRI CARTIER-BRESSON, BERNARD COLE, JACK DELANO, MARY C. DICKERSON, WALKER EVANS, ANTONIO A. FERNANDEZ, STEVEN D. FOSTER, ALEXANDER GARDNER, PHILIP GUDWIN, LEWIS W. HINE, HENRY HUMPHREY, MARTIN IGER, JOHN R. KENNEDY, IRWIN KLEIN, DOROTHEA LANGE, RUSSELL LEE, RON MESAROS, T. H. O'SULLIVAN, FRANK OVERTON, ARTHUR ROTHSTEIN, JACK ROSENTHAL, HELENE RYDSTROM, CHRISTOPHER SCHUBERTH, JON SINISH, JEFF SIMON, NEAL SPITZER, JAMES STEVENS, JOHN VACHON, EDWARD WESTON, DOUG YULE.

Thanks are also due the following individuals and organizations who assisted the author in many different ways: Bill Joli, Bob Satter, Margaret Morris, Elizabeth Weiss, John Weiss, Carla Stevens, The Eastman Kodak Corporation, The American Museum of Natural History, The Department of the Navy, The Save-the-Redwoods League, Honeywell, Inc., The George Eastman House, The Library of Congress, The Standard Oil Company (N. J.), Gossen Luna-Pro Company, E. Leitz, Inc., Simmon Omega Corporation, Ponder and Best, Inc., Calumet, Inc.

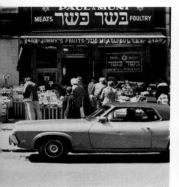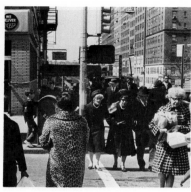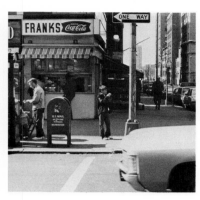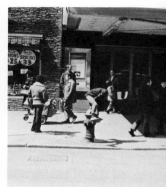

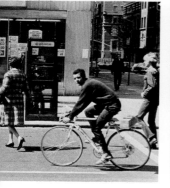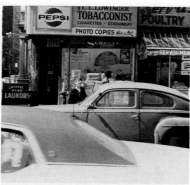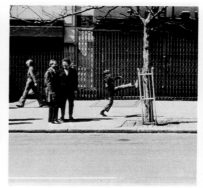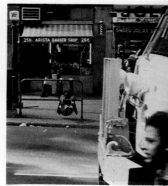

H. WEISS

Introduction

Seeing and Remembering

There is a constant stream of images always passing before your eye. There are people, places, all kinds of things happening . . . a million fascinating sights. Your eye sees all this. Some of it is remembered. Most of it is forgotten.

The camera is like your eye. It sees what you see. But in one way it is better than your eye. It has a more accurate memory. It can produce a permanent visual record.

You, the photographer, must *see* and *select* that particular action, person, scene that you think worth remembering. You must see and recognize from among all the busy, confused world around you what is most interesting, exciting, beautiful. The camera will record that moment you select. When you make the decision to click the shutter, that moment will be always "remembered."

Don't think that you must have a very fancy camera to take good pictures. Some of the finest photographs have

7

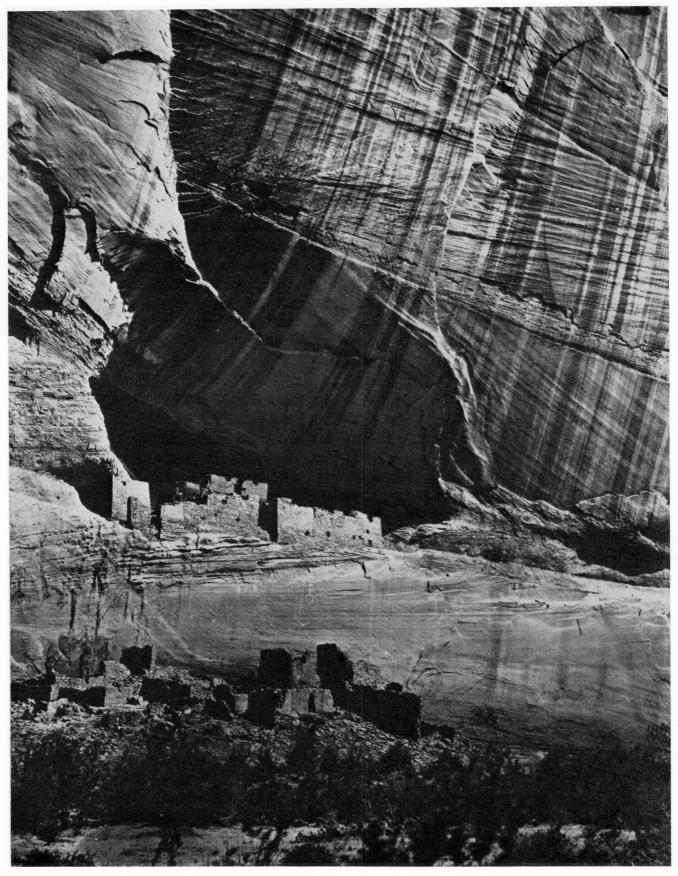

T. H. O'SULLIVAN

been taken with crude or primitive cameras. And some of the most dull and uninteresting pictures are taken by amateurs with the most elaborate and expensive equipment. The photograph on the facing page was taken in 1873 using cumbersome, awkward techniques and equipment that bear little resemblance to the cameras and darkroom methods of today. Even so, this is a very beautiful photograph.

This book explains how to use both the simple and the more advanced types of camera. Even if you happen to have a very simple camera with lens and shutter that is not adjustable, you should still read the first chapter because all cameras work basically the same way. Some day you will probably own a more advanced camera and will need to know how to use it.

Once you understand the basic principles of camera operation you can get on to the more important business of taking pictures. The photographs reproduced in this book and the discussion of them will help you learn what to look for to get interesting, meaningful, exciting pictures that you will want to share with your friends and look at again and again.

PART ONE
THE CAMERA

How a Camera Works

A camera is basically a lightproof box. One end of the box holds film. The other end has a hole that can be briefly opened. When the hole is uncovered, light reflected off any object in front of the box travels through the hole and strikes the film. In actual practice a lens is placed in front of the opening in the box. The purpose of the lens is to gather and concentrate the light onto the film.

The illustrations on this and the opposite page show the most common types of cameras.

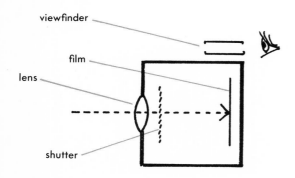

This is the simplest kind of camera, sometimes referred to as a "box" camera. The focus is fixed and every-

thing from about five or six feet and beyond is in focus.

10

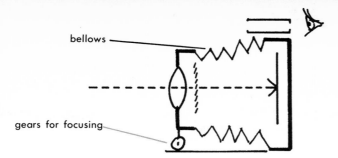

bellows

gears for focusing

This is a bellows type of camera. The front part can be moved back and forth in order to get the sharpest image. There are many variations of this kind of

camera. The one shown here requires a large negative and is used in commercial studios.

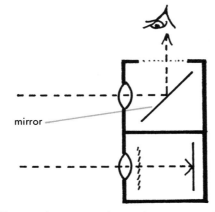

mirror

Here we have a twin-lens reflex camera. The lower half has the "taking" lens and film. The upper half serves as a viewfinder. You look down into the view-

finder and see the picture you are about to take on the ground glass screen. The two lenses move back and forth together for focusing.

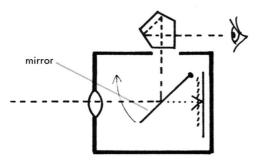

mirror

This is a 35 millimeter, single lens reflex camera. (It is usually referred to as an "SLR.") The image is reflected off a mirror, then through another system of reflectors to your eye. When you press the shutter,

the mirror quickly lifts up out of the way. While it is lifted, a shutter "curtain," which is like a small window shade, passes in front of the film, exposing it. Then the mirror drops down again.

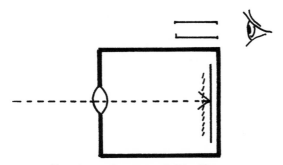

Here is another type of 35 millimeter camera which looks very much like the one above. But it doesn't have the mirror. It has a separate viewfinder. Today, 35

millimeter cameras are very popular—especially the SLR type, shown above. They are small, versatile, and easy to use once you become familiar with them.

11

Film is a thin sheet of plastic with a thin coating on it called an *emulsion*. The emulsion consists of tiny grains of silver salts held together by a jelly-like substance. These salts are sensitive to light—they change when light hits them. When you take a picture some salts are struck by a lot of light and change a lot. Other salts are struck by less light, and don't change so much.

When the exposed film is treated with various chemicals (or developed) the silver salts which have received a lot of light remain in the emulsion. The silver salts which have received little or no light are dissolved and washed away. Therefore the film (which we now call the *negative*) looks dark where light struck the film, and transparent where no light struck the film. You've no doubt looked at negatives and noticed that a person with a white shirt and black tie, for example, seemed to have a black shirt and white tie.

A negative is of no use in itself—everything is reversed. But it is needed in order to make the final positive print, in which you finally get to see the person, place, or object that you photographed. (At the end of this book there is more detailed information on how you can develop film and make your own prints.)

Focusing

The more simple, inexpensive cameras have a fixed-focus lens. This means that everything from about five or six feet to infinity is sharp—in focus. No adjustment is possible. The more advanced cameras, however, have a lens that must be focused for each shot. In this way the sharpest possible image can be obtained. Focusing is done by altering the distance between lens and film. In some cases the entire front part of the camera can be moved back and forth by means of a gear arrangement. On smaller cameras, the lens and its housing screws in or out. Distant objects require a short space between film and lens. For close-ups the lens is moved farther away from the film. In all cameras that can be focused there is some kind of scale that shows where the lens should be posi-

tioned for what distance. In some cameras there is a focusing screen that you look through, and by moving the lens back and forth, you can see for yourself when the image is sharpest.

How to Get the Correct Exposure

There is one basic fact about film which you must know if you are to understand lenses, shutters, and a lot of the other operations that go along with getting a camera to do your bidding: the film must receive exactly the right amount of light if it is to produce a satisfactory image. Too much light or too little light will result in either no picture at all or a poor one. When the right amount of light reaches the film you have what is called the correct exposure.

There are two devices on every camera which determine how much light gets to the film so that you can obtain the correct exposure. One is the *shutter,* the other is the *diaphragm* (pronounced die-a-fram).

The Shutter

The *shutter* is like a little window shade which is opened very briefly so that light can pass through the lens to the film. On the simpler cameras it is not adjustable and is open for approximately 1/50th of a second. With cameras that have an adjustable shutter you'll usually find this choice of shutter speeds: 1, 2, 4, 8, 15, 30, 60, 125, 250 and sometimes 500 and 1000. The "1" stands for 1 second. The "2" stands for 1/2 second, the "4" for 1/4th second, "100" for 1/100th second, and so on. The longer the shutter is open, the more light will reach the film. Twice as much light reaches the film with a 1/30th shutter speed as with a 1/60th shutter speed.

There is also on some cameras a "B" and a "T" position. The "B" stands for "bulb" and means the shutter stays open as long as the shutter button is depressed. The "T" (which stands for "time") means that the shutter opens when the button is pressed and then remains open until it is pressed a second time. This is called a time exposure.

The shutter is important for another reason. It serves to "stop" action. If your shutter is open for any length of time, and your subject moves during this time, you will get a blurred image. If you set your shutter at 1/50th of a second you are limited to pictures of objects or people that are pretty much standing still or moving only slowly. At 1/100th of a second you can get a clear picture of movement, such as somebody walking, or perhaps a bicycle moving slowly. With the shutter open for only 1/500th of a second you can "stop" almost any kind of motion.

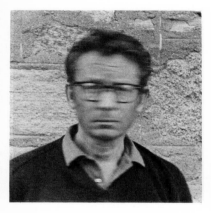 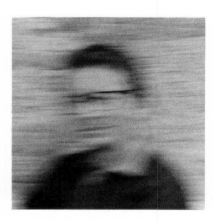

Here the subject moved too fast for the shutter. The shutter was set at 1/50.

Here the subject was standing still, but the camera wasn't held steady. The shutter was set at 1/50.

In this picture the camera was held steady and the subject did not move.

But there is one kind of motion that you must avoid at all costs. That is the motion of the camera itself! This is particularly important at slow shutter speeds. With your shutter set at 1/50th of a second, for example, you must hold your breath, then very slowly and evenly click the shutter so that there is no movement of the camera. If you use slow speeds—below 1/50th of a second—you must put your camera on a tripod, or on a table, or in some way see that it is absolutely steady.

The Diaphragm

The *diaphragm* in the simpler cameras is a thin sheet of metal with different size holes. It is placed behind the lens and can be rotated—the smaller the hole, the less light that comes through. The better cameras have a different

14

type of diaphragm which consists of many thin metal leaves. These are adjustable so that the size opening can be changed from a wide to a very small one. The size of the diaphragm opening is described by "f/stops." The f/stops on an average camera will go something like this: f/2, f/2.8, f/4, f/5.6, f/8, f/11, f/16, f/22. The *lower* the f/number the *more* light that comes through.

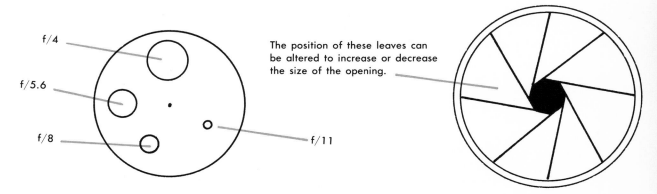

With each step up, the amount of light reaching the film is halved. For example, if you change from f/4 to f/5.6, which is one step, you are cutting in half the amount of light passing through the lens. And likewise, if you shifted from f/4 to f/2.8 you would be doubling the amount of light reaching the film.

As you can see, both shutter and diaphragm allow you to control the amount of light reaching the film. But what amount is the right amount? And how do you get this information? With some films there is a slip of paper which gives recommended exposures. This slip will have a little table like the one shown below.

Kodak Panatomic-X film.			
Shutter speed 1/100		Shutter speed 1/50	
Bright or hazy sun (Distinct shadows)	Cloudy Bright (No shadows)	Heavy overcast	Open shade
f/8	f/4	f/4	f/4

This table tells you that a shutter speed of 1/50th of a second and a diaphragm opening of f/4 will be the correct exposure for pictures taken on a heavy overcast or cloudy day. This table is for Kodak Panatomic-X film. With some other films the exposure information is printed on the paper backing of the film itself, and when you load the film into the camera you will see the recommended exposures. This is the case with Verichrome-Pan, which is the most popular all-around film.

This is the kind of exposure information you will find on a roll of Kodak Verichrome-Pan:

Bright sun	1/100	f/16
Light overcast	1/100	f/11
Heavy overcast	1/100	f/8

Films

The light requirements of different films vary. Films that don't need a lot of light are called "fast." Films that require more light are called "slow." And their fastness or slowness is referred to as *speed* and shown by an ASA number. (The letters ASA stand for American Standards Association.)

The Kodak Panatomic-X has a speed of ASA 32. Kodak Tri-X film has a speed of ASA 400. The Tri-X is a much faster film. The recommended exposure for pictures taken on a heavy overcast day for Tri-X is 1/200th or 1/250th second at f/8. With this exposure a lot less light is reaching the film than with the recommended exposure for the slower Panatomic-X film.

As you can see there is quite a choice of films. Which do you use when? You would want to use a fast film, like Kodak Tri-X, if you expected to be taking pictures with dim light, perhaps indoors, or you would use it if you planned to take photographs of fast action that would require very fast shutter speeds.

(The films referred to here are all black-and-white films. Color films such as Kodachrome, Ektachrome, Agfachrome, which are discussed in Chapter 9, are generally slower than black-and-white films. Their speed is also indicated by an ASA number. A popular color film like Kodachrome X, for example, has a speed of ASA 64.)

The slower black-and-white films, such as Kodak Panatomic-X, have a special characteristic. They are "fine-grained." This means that they can be greatly enlarged and the silver salts (or grain) in the film emulsion will not be as noticeable as with the faster films. In other words, a slower, fine-grained film is more desirable if very big enlargements are planned.

Cameras with no shutter and diaphragm adjustments usually use a general purpose, average speed film such as Kodak Verichrome-Pan, which has an ASA speed of 125.

There is another way of finding the correct exposure in any situation. It requires the use of an exposure meter, which is a device that measures the amount of light that you have to work with. It is described in Chapter 10.

Let's take an imaginary situation and see how some of the information explained here is used. Suppose you wanted to take a picture of someone in the shade skipping rope. Your film is Verichrome-Pan and the recommended exposure is: 1/50th at f/8. However, your subject is skipping rope at a pretty fast rate of speed. A slow shutter speed like 1/50th of a second will give you a blurred picture. (Fast motion needs a fast shutter speed.)

Change your shutter speed to 1/100th of a second. That will probably stop the action. But now, not enough light is getting to the film. You must let in more light. And you can do this by opening up the diaphragm. Change from the recommended setting of f/8 to the next larger setting: f/5.6.

Now you can stop the action without any blurring, and still have a correctly exposed film.

Depth of Field

This is one more thing to bear in mind when you are adjusting your diaphragm opening. Depth of field refers to the area in front of your camera in which everything will be in focus. In the photographs on the next page you can see the difference between a wide and a narrow depth of field.

Depth of field is determined by the diaphragm opening. The wider the opening the smaller the depth of field.

In this photograph the diaphragm was opened up to its widest setting. Only a small area of the picture is sharp. The setting was f/2 at 1/1000.

For this photograph the diaphragm was closed down to f/16. Just about everything is in focus now.

At f/2 the depth of field is small. At f/16 it is very large . . . everything from fairly close to infinity can be sharp. ("Infinity" as used by photographers really means from fifty or sixty feet and beyond.)

Automatic Cameras

Some of the newer, more sophisticated cameras make many of the decisions and do much of the work that the photographer used to have to do himself. There are some cameras with automatic exposure devices, for example. You point the camera at your subject, choose the shutter speed you want, and then the diaphragm opening is automatically set by a tiny, built-in motor that is controlled by an electric eye! You focus, click the shutter, and can be sure of a perfectly exposed picture.

You are probably familiar with the Polaroid Land camera which has many automatic features and which takes a picture in black-and-white or color, and within a few seconds, develops and prints it. One of the advantages of this camera is that if you see something isn't quite right in your first print, you can quickly make another.

There is such a great variety of cameras today with individual, special features that it is impossible to describe them all. If you have a new camera, read the instruction book that comes with it very carefully. If you are using an older, hand-me-down camera, get somebody who un-

derstands it to explain all its special, out-of-the-ordinary features. Then, before you load it with film, experiment with it as much as possible. Click the shutter, adjust the focus, open and close the diaphragm, fiddle with all the gadgets and adjustments until you are completely familiar with them. Practice taking pictures *without* any film in the camera.

Practice

If photography is something new to you, the information on the preceding few pages may take a little "digesting." You'll have to take a good many pictures, and no doubt make a good many mistakes, before you become familiar with all the variations and possibilities of shutter speeds, depths of field, and so on. Start out by limiting yourself to the simpler kinds of subjects. Follow the instructions for shutter and diaphragm settings that come with the film, and you will get good results. Then, as you gain experience, you can move on to more difficult subjects.

Later on in the book you will find information on some more advanced techniques such as the use of flash, filters, special lenses, exposure meters, and so on.

A Helpful Hint

When you buy film, try to get it from a camera store or a large store that has a camera department, rather than at a drugstore or candy store. Stores that sell photographic equipment will have someone who knows about photography and who can advise you. A good-natured camera store salesman who will take the time to answer your questions and give you the specific help you may need is someone worth looking for.

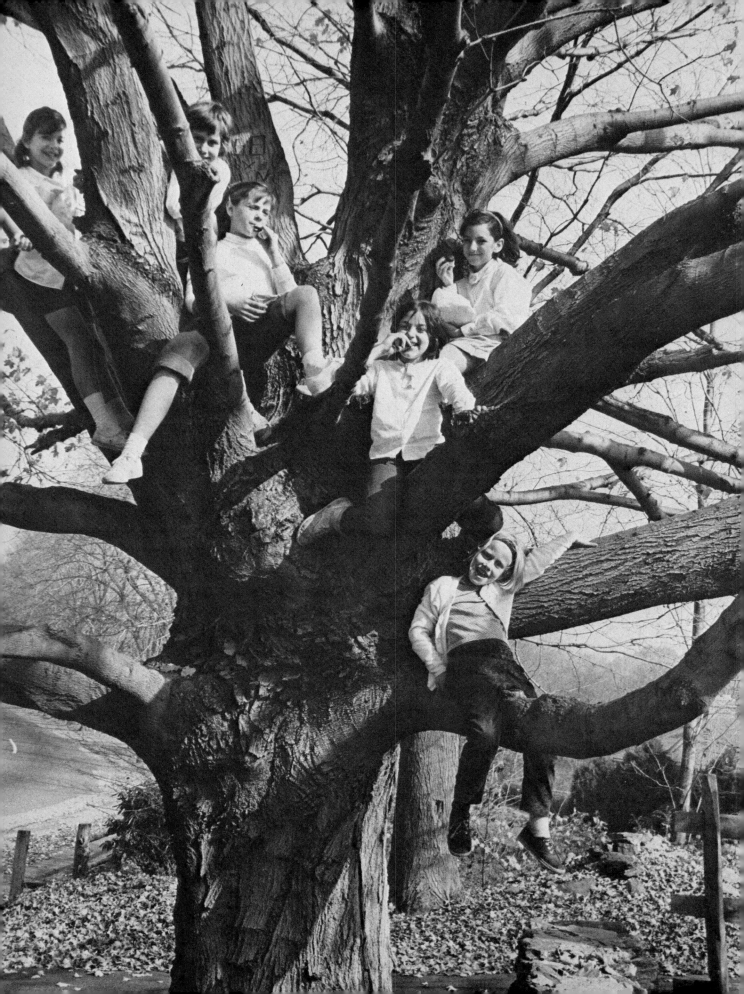

PART TWO

TAKING PICTURES

1. Pictures of People

The last section discussed the camera as a "machine"—a tool with which to make pictures. Now—in the rest of this book—we will see just *what* we can make with this tool.

In this first chapter we discuss only taking pictures of people. After all, this is one of the most popular uses of the camera. And in taking pictures of people we will meet up with the business of lighting and with some of the other problems and conditions constantly occurring in all kinds of photography. Most of the ABC's of picture-taking are dealt with here, and you will find it worthwhile to take a picture in each of the different situations described, and keep it as a reference.

How Close

Pick a nice, sunny day. Load your camera with film. If you have a simple camera without any adjustments, you don't have to worry about diaphragm or shutter speed

settings. If you do have a camera which must be adjusted, you've read the first section of this book—so you know all about it and you've set the camera for a sunny day under open skies!

Find somebody who will be willing to spend a little time posing for you.

Before you start taking pictures you must decide how far you want to be from your subject. Looking through the viewer of your camera will show you just what will be included within the frame of the picture. Try to get as close as possible; otherwise you may get a picture like the one shown, where your subject is dwarfed by the surroundings. That kind of picture may be all right if you want a picture of sky and clouds. But if you want a photograph in which you can recognize the subject, you must get close. With most cameras you can get as close as five feet.

Background

Now think about what is *behind* your subject. This is terribly important. The background will be a part of your picture and you mustn't let it be confusing or distracting. Simple, large areas like sky, distant trees, blank walls make good backgrounds. (If you have a camera with adjustable shutter speeds and diaphragm settings you can throw a disturbing background out of focus to keep it from being distracting. See "Depth of Field," page 17.) This is a trick many expert photographers frequently use.

Take a quick look at the photographs in this book, paying attention only to the backgrounds. You'll see that in many cases it is very plain and simple, and that in no case does it intrude upon or confuse the main purpose of the photograph.

These two photographs were taken in exactly the same place. The upper picture was taken with the camera set at f/8 at 1/60. In the lower picture the setting was f/2 at 1/500. At f/2 there was little depth of field and the background is out of focus.

Flat Lighting

Now, about lighting. Have your subject face the sun. Several things will happen. For one thing, the eyes will squint. Secondly, if it is early morning or late afternoon when the sun is low, it will be shining directly in the face so that there are no shadows. This is called flat lighting and doesn't show very well the shape or modeling of a face. The shape of people, landscapes, or any object is to a large extent indicated by shadows. Without shadows—as in the photograph on the right—everything looks very flat. (Flat lighting is not objectionable with color photographs because the color helps to show the form.)

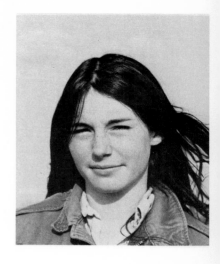

Side Lighting

Have your subject turn so that the sun will strike from the side. As you can see, now there is a strong and contrasting pattern of light and dark. Now, the shadow side of the face is much too dark. Even so, this is an improvement over the flat lighting.

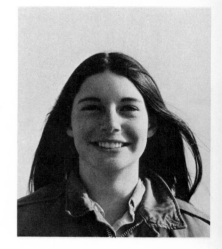

Using a Reflector

Here we have the same side lighting used in the previous photograph, but a very useful trick has been used to get a little light into the shadow part of the face. A large white cardboard has been held in such a way that it reflects some of the sun back into the shadows. As you can see, it makes quite a difference. If you can't find a cardboard with a white surface, you can take any kind of large board and cover it with wrinkled aluminum foil and get the same results. It is also sometimes possible to get light reflected into the shadowy side of a face by placing your subject near a large white object, such as a fence or the side of a house.

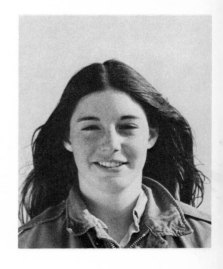

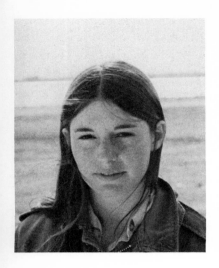

Back Lighting

Next, see what happens when the sun shines directly behind your subject. This is called back lighting, and often the thin edge of light you get along the back of your subject is quite dramatic. You must be careful, however, to see that the sun doesn't shine directly into your lens, or you may get all kinds of streaks and glare marks on your film.

This kind of lighting is not usually used without additional lighting from another source because, by itself, you will often get simply a silhouette. In the photograph shown here, a cardboard reflector has been used to reflect some light into the shadowed part of the face.

Remember that you are now taking a photograph of a face that is in shadow, even though the subject is standing in the sun. There is less light on the face. If your camera has an adjustable shutter and diaphragm you might want either to open up the diaphragm a couple of steps—or else to use a somewhat slower shutter speed. Otherwise the face will not be properly exposed. This is a tricky kind of lighting that requires a little practice to get used to.

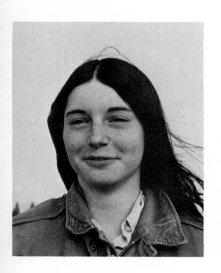

Diffused Light

Next, try taking your model out of the direct sunlight. Find a spot where the sun is blocked by a big tree or a building. See the kind of light on your subject now. The shadows are softened and the effect is less harsh. You will probably decide that this is the best general-purpose kind of light. This is a gentle, overall kind of lighting that is not as dramatic as the sharp, crisp, direct light of the sun. But it actually shows more. It is called a diffused light.

Your exposure will have to be adjusted if you move your subject from the sun to a shaded spot because, obviously, you'll have less light to work with.

Opposite, JEFF SIMON. You can tell by the soft, even light that this photograph was taken on an overcast day in diffused light. There are no hard shadows.

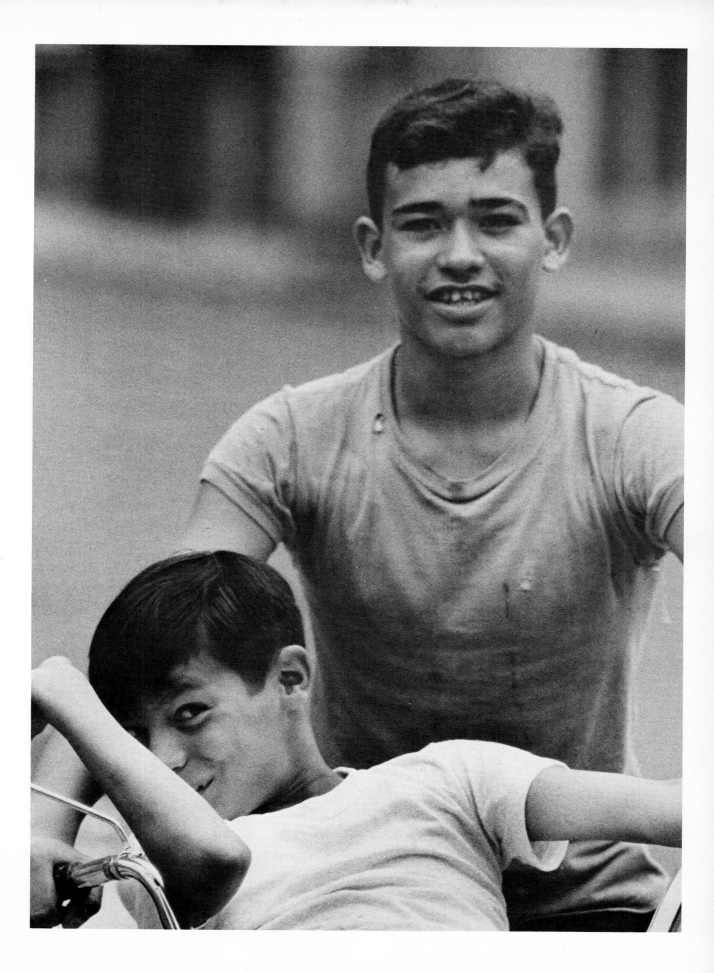

Expression and Character

So far we've discussed lighting and backgrounds, which are certainly important. But what is much more important is the person you are taking pictures of. A clear, well-lit head with a nice background and the features all present and accounted for does not necessarily make a good photograph. A good photograph should tell you something about the subject—or the way you feel about the subject. Otherwise you may get the sort of "mug" shot that police use for identification.

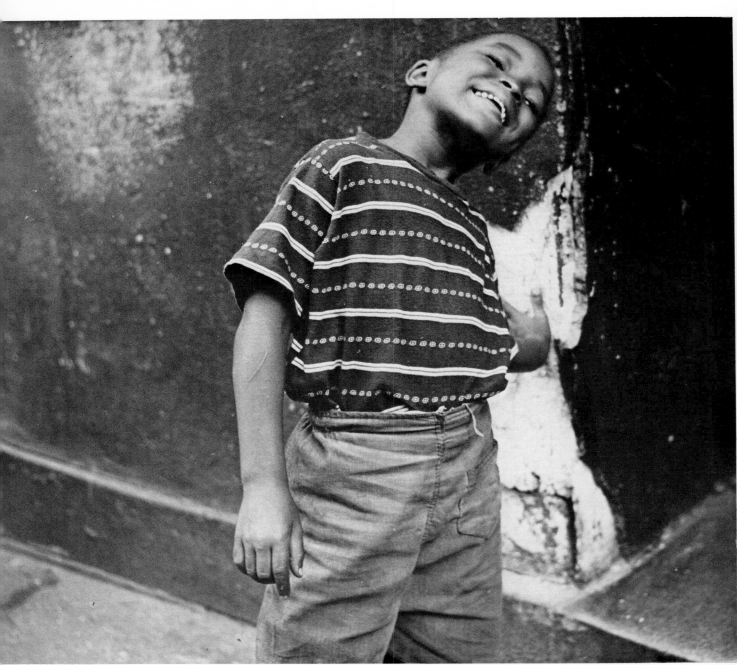

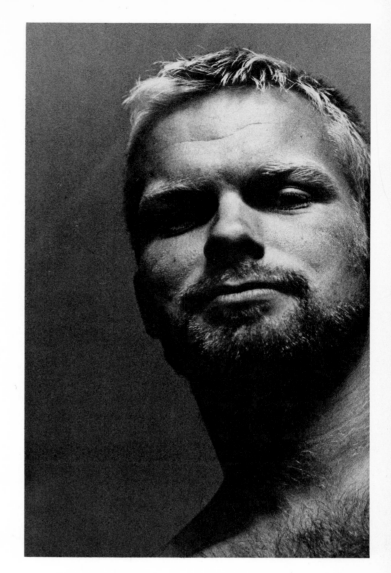

Opposite, JACK ROSENTHAL. The photographer was alert enough to click the shutter at just the moment when the smile and gesture were most expressive.

Right, JAMES STEVENS.

Below, JACK ROSENTHAL. Getting close helped to capture the feeling of intense concentration.

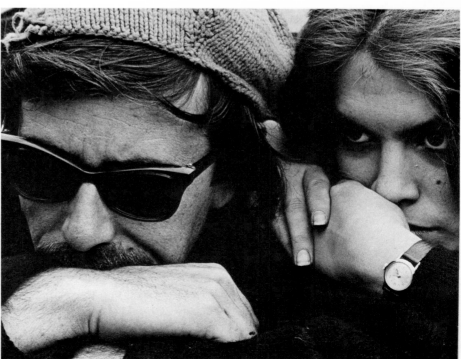

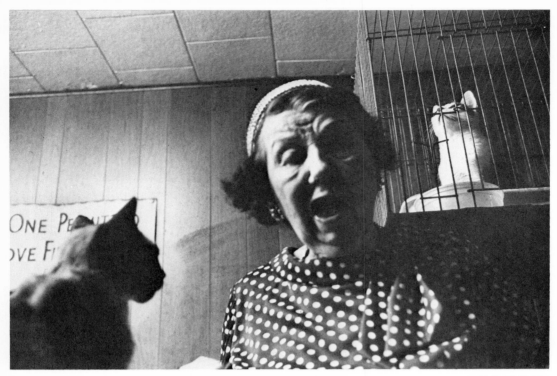

PHILIP GUDWIN

NEAL SPITZER. In both this photograph and the one above, you learn a good deal about the subject— partly from the surroundings, partly from the facial expression.

Photographers often get into conversation with their subjects when taking portraits. When a person is concerned with what he is trying to say, he doesn't have the opportunity to "freeze up" and some of his natural expression and manner will come through.

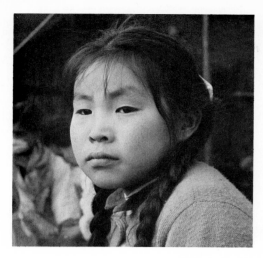

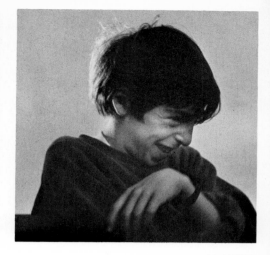

JAMES STEVENS H. WEISS

A good photograph of someone should have personality and character. How do you, the photographer, recognize and capture this on film? You do it by deciding what is special or distinctive about your subject. For example, if you are taking a picture of someone who is a cheery, happy soul, wouldn't it be logical to try to photograph him in this kind of mood rather than standing stiffly staring at the camera with a blank look?

Very often the character and personality of a person are apparent when he is *doing* something, rather than just posing. In the picture of the little boy laughing, this active and lively expression was caused by a little gentle tickling as the picture was snapped. This is an artificial way to get a response, but it worked, and the result is a portrait that is full of animation.

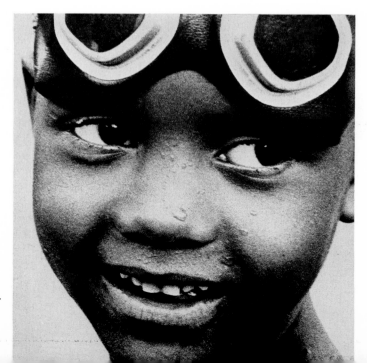

JACK ROSENTHAL 29

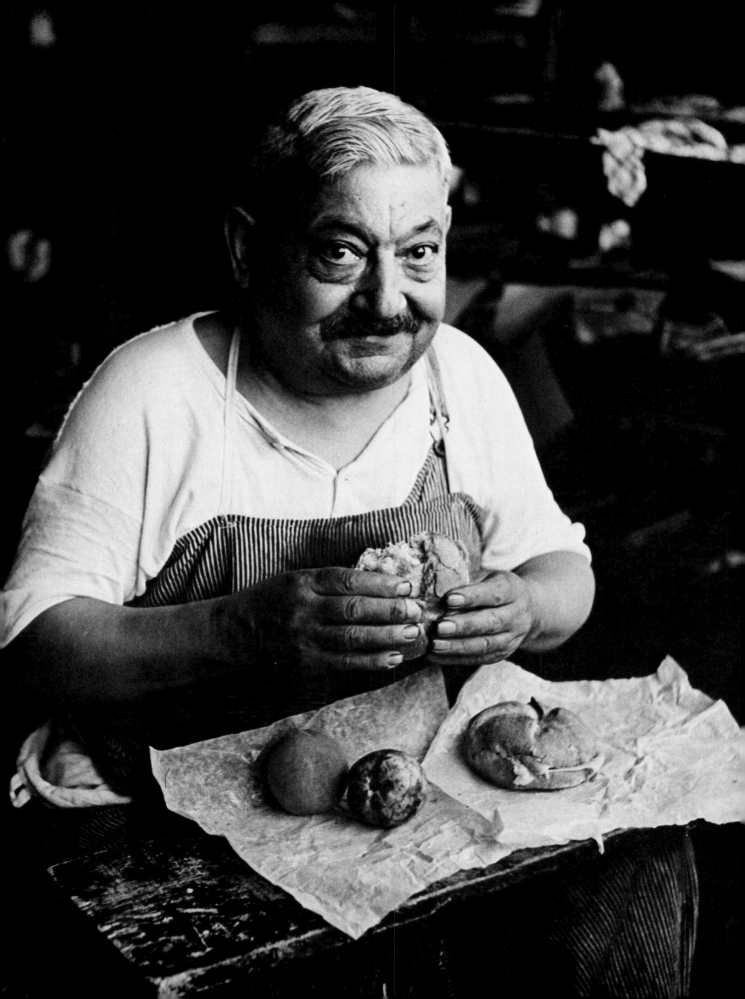

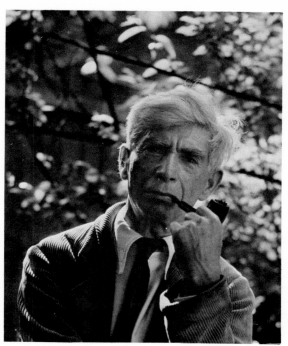

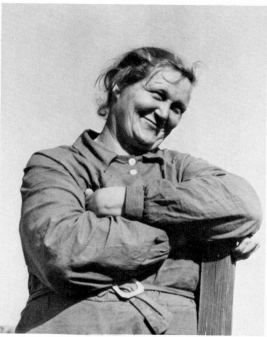

H. WEISS. This is a good example of back lighting.

DOROTHEA LANGE. The harsh light of the direct sun suited the rugged character of this farm lady.

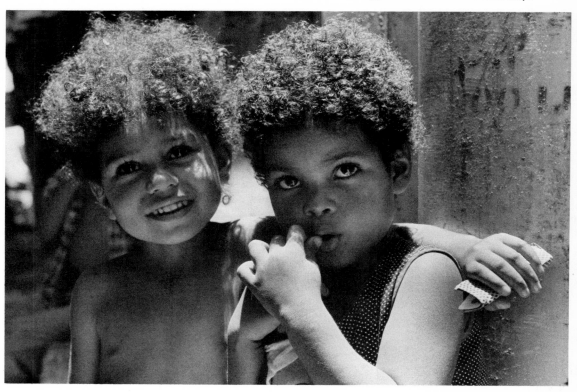

MARCIA KAY KEEGAN

Opposite, BERNARD COLE. Everything about this photograph tells you that this shoemaker is a gentle, good-natured human being.

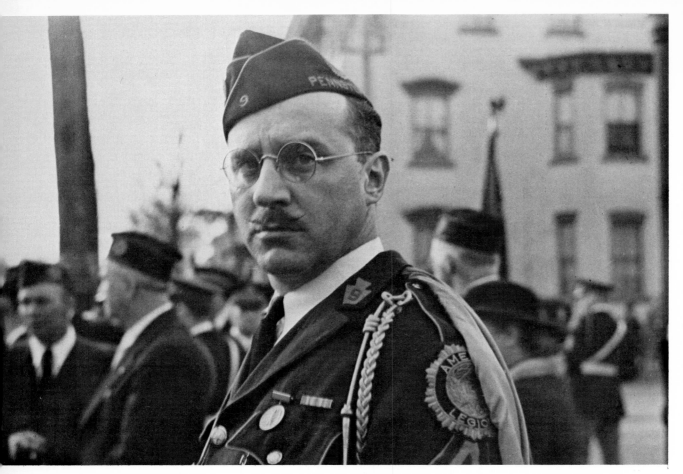

Candid Photography

Candid photography is another way of photographing people. It is a split-second glimpse of someone surprised by the camera or caught unawares. The results you get are very often quite interesting because you can capture expressions, gestures, actions that are completely natural and unposed.

It is a rather special kind of photography because the photographer tries to remain unseen, ignored, or forgotten. One way to get good candid shots is to stay around your subject, fussing with your camera, or doing something else, until he gets so used to having you around he finally ignores you. This may take quite a bit of time, but no one will pay attention to you for more than a few minutes before getting involved with other things. A good technique is to get near your subject—but facing in a different

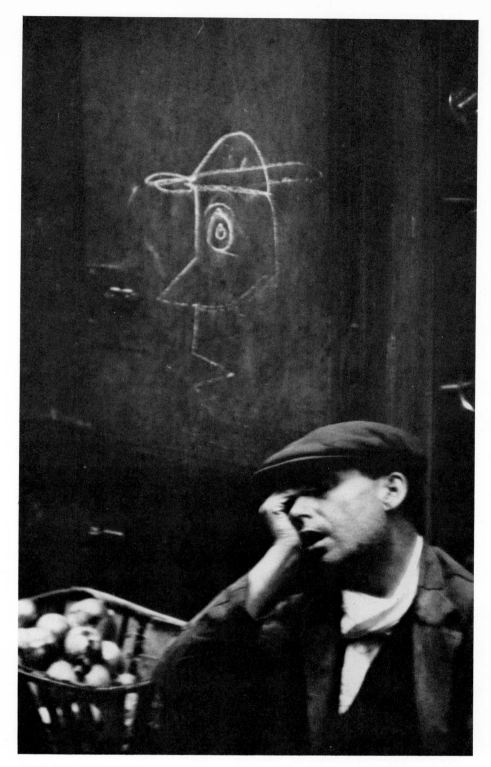

HENRI CARTIER-BRESSON. A good photographer must have the sort of imagination and alert eye that can see the chalk drawing on the wall repeated in the pose of the sleeping man. A thousand people might walk by this scene and think nothing of it. But a great photographer like Cartier-Bresson will be quick to see and record its humor and human interest.

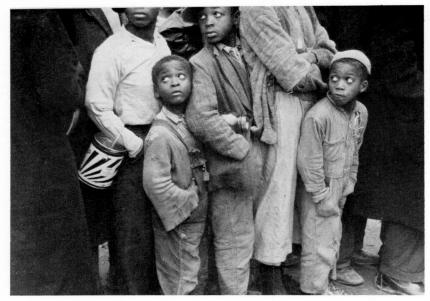

direction. Then quickly turn around and take the picture before anyone notices what you are doing.

A candid photograph is usually taken fast. You see a situation, an expression, a gesture, and quickly you point the camera and click the shutter! There isn't time to fuss around with focusing or adjusting diaphragm and shutter. This means that if there are any adjustments to be made they should be made ahead of time. If you suspect you are going to want to get a picture of someone, for example, who is ten feet away, sitting in the shade, get the camera focused for ten feet, and make any necessary adjustments for those light conditions. Then you are all set to go when you see the right moment.

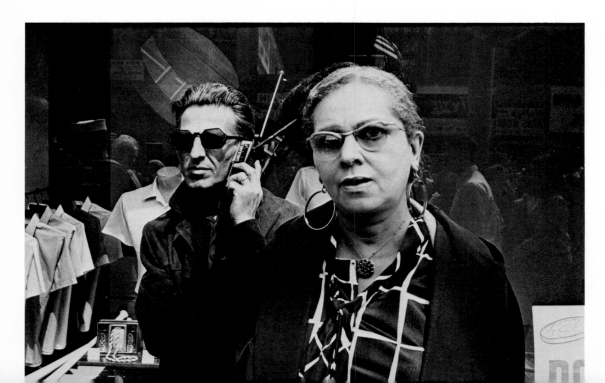

DOROTHEA LANGE

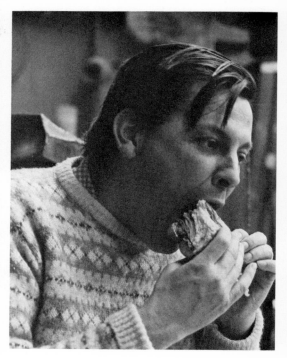

H. WEISS

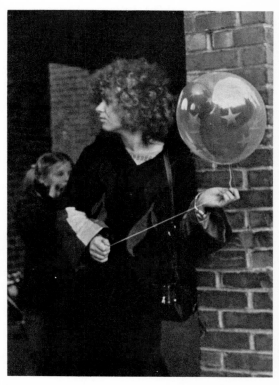

FENTON T. BENTON

Opposite, STEVEN D. FOSTER. This was taken during a protest march in Chicago. You can see the marchers reflected in the store window. The picture has a very strange, almost unreal quality. One wonders about these two people—who they are, what they saw, what they thought, and what they did after the photographer took their picture and left.

35

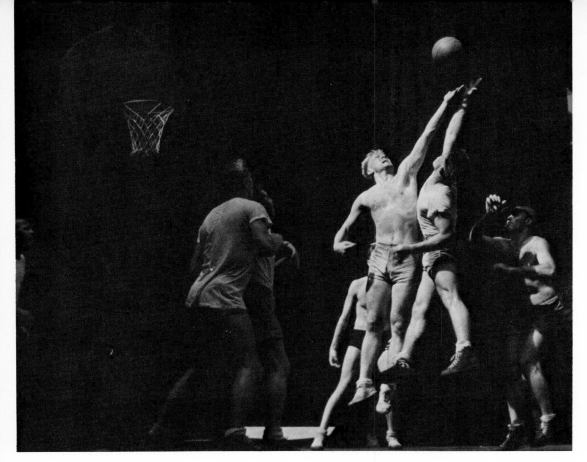

U. S. NAVY PHOTOGRAPH. Even a slow shutter speed would be able to catch this action because the shutter was pressed at the peak of the action when the figures and the ball were actually almost motionless. Notice how the action is dramatized by the deep shadows of the background and the sunlight on the center of interest.

Below, JON SINISH. This is simple, violent action frozen by a fast shutter speed.

2. Action

One of the things that the camera does best is record a brief instant in time. When you click the shutter that particular moment is stopped and permanently recorded on your film.

But there are some moments difficult to record simply because they are too fast. Unless you have a camera with a fast shutter it is best to avoid pictures of anything in fast motion. There are some actions you can't get without special high-speed equipment. For example, you couldn't get a race car speeding by directly in front of your camera lens even if you had an expensive camera with a fast shutter speed. The simpler cameras with the one shutter speed, which is usually about 1/50th of a second, are not fast enough to stop anything moving quickly.

There are several things you can do when you want to photograph action and you don't have a speedy shutter. The most effective thing is to try and find that instant when the action is at a peak—or between violent movements. For example, somebody on a swing is motionless at either end of the swing motion. If you press the shutter at that moment, you will stop the action with no difficulty.

When there is continuous fast motion without a pause, your best chance of getting a picture that isn't blurred is to photograph your subject at somewhat of an angle—so that the subject is coming toward you or moving away from you—rather than passing directly across your line of vision. This way there is less motion.

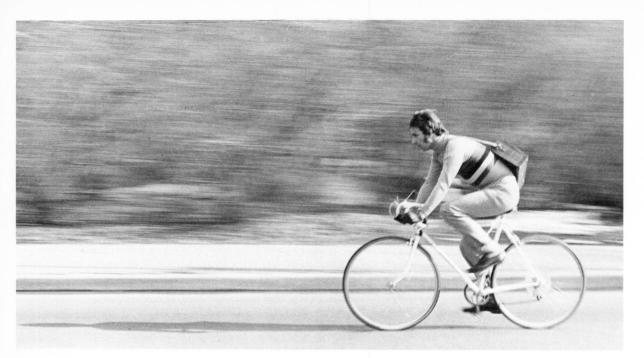

FENTON T. BENTON

Panning the Camera

Another interesting trick for stopping fast action is "panning" your camera. This means swinging the camera along with the action, as if it were a movie camera. This can be done with even the simplest camera. You should use a smooth motion, clicking the shutter as your subject goes by. (Make sure you "follow through." In other words, keep the camera moving even after you click the shutter.) You will get the sort of result shown above. The bicycle and the figure on it are quite clear and the background is blurred.

A blurred image is not always undesirable. Sometimes it will give a photograph a feeling of motion. In the photograph below a shutter speed of 1/10th of a second was used. This is quite slow and part of the figure is blurred. But this was the effect that was intended.

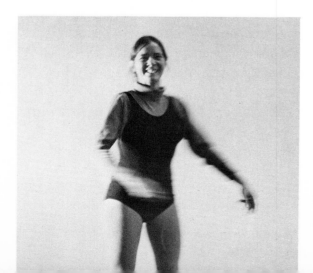

H. WEISS

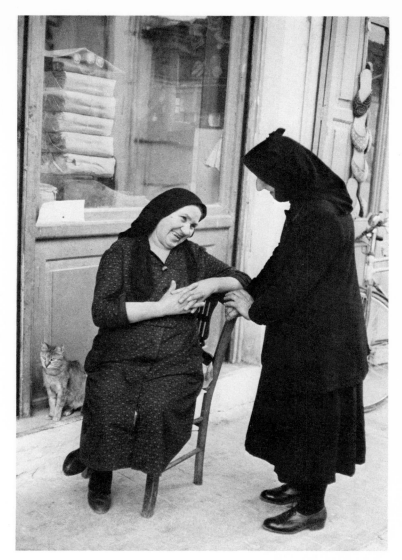

The Right Moment

There is another kind of action that the good photographer always looks for. It is not necessarily the sort of action where there is a lot of physical motion. It may be the action of someone suddenly smiling, or a brief shrug of the shoulders, or a raised eyebrow, or two people exchanging a special kind of look. Or it may be the moment when the shadow of a tree falls on the side of a fence. It may be the instant when a sailboat is passing in front of a lighthouse, or when a big cloud is positioned just the way you want it behind a hilltop.

There are things happening everywhere you look, at every instant; the problem of the photographer is to look

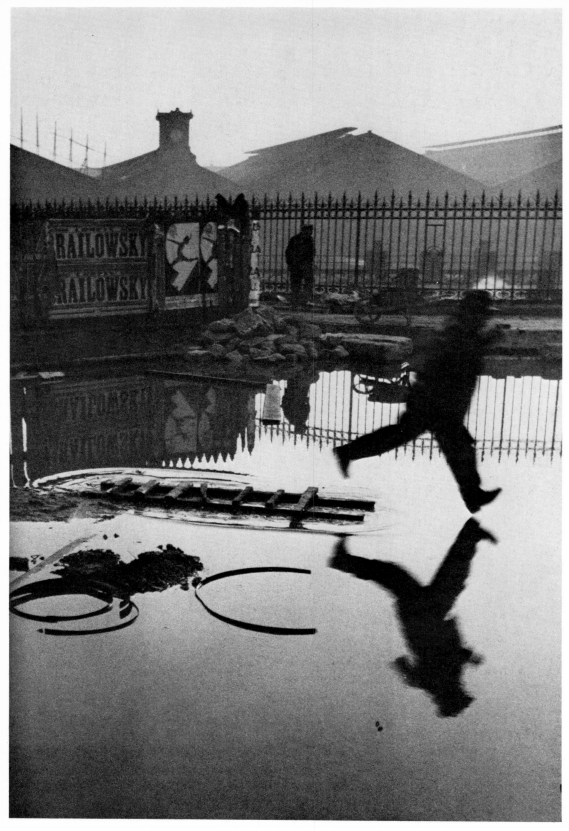

HENRI CARTIER-BRESSON

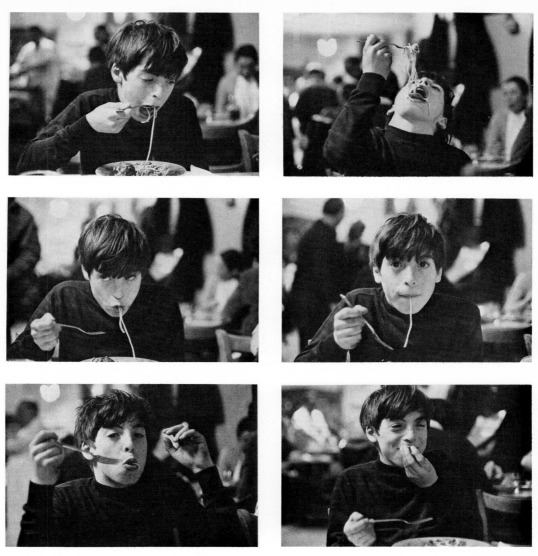

for them and to choose the particular instant that he thinks best.

This ability to see and recognize this "right moment"—the moment that is most revealing, most dramatic—is certainly one of the more important skills of the photographer.

The six photographs of the boy eating spaghetti are an example of what the "right moment" means. The photographer, who in this case, is the author, was trying to capture the most exciting and vivid moment in the course of a meatballs-and-spaghetti dinner! Some of these moments, more than others, have the essence of "spaghetti-eating."

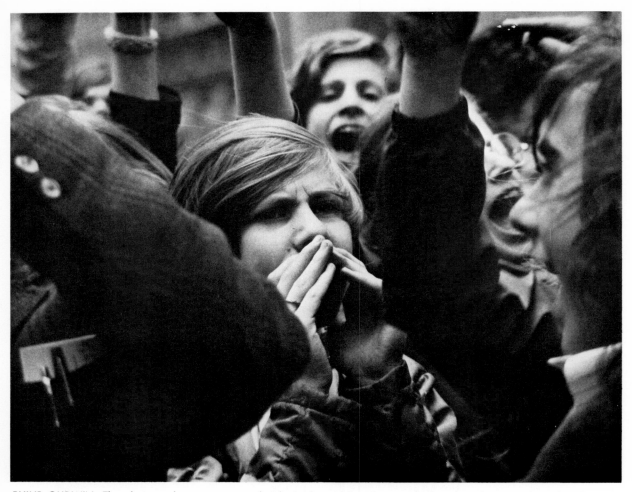

PHILIP GUDWIN. The photographer was squeezed right in the middle of a crowd of student demonstrators when he took this picture.

Opposite, EDWARD WESTON. There is motion here, too. A little earlier or a little later in the day and that very lovely, delicate line along the edge of the sand dune wouldn't have been there.

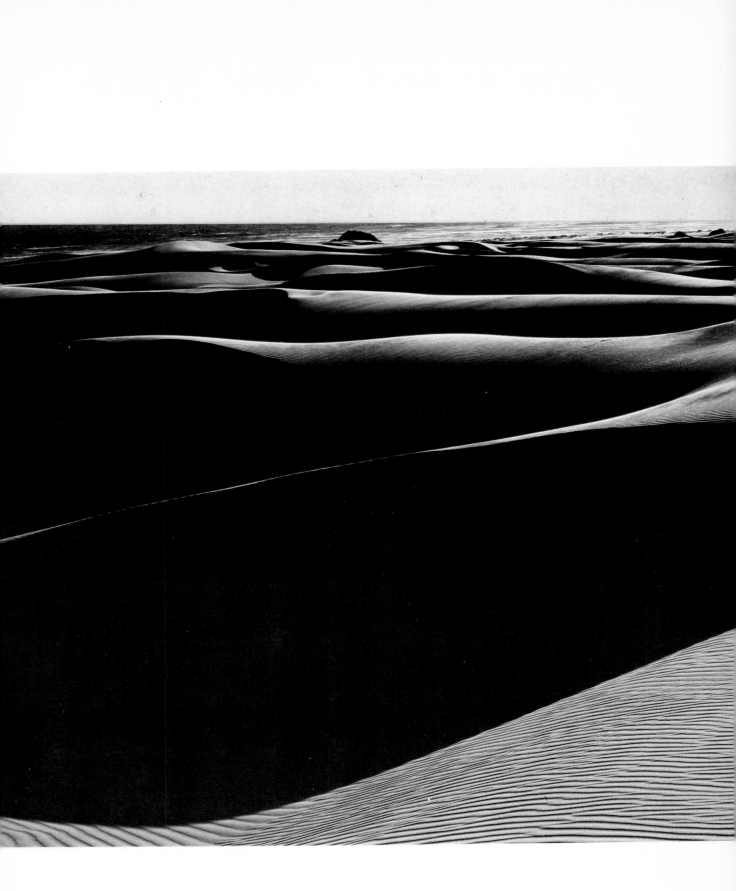

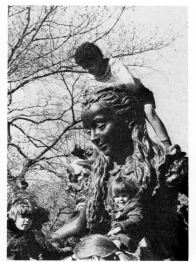
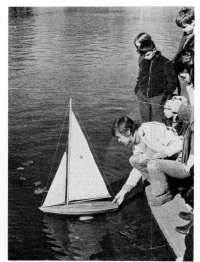
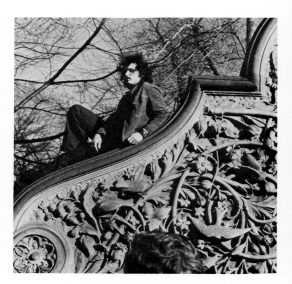
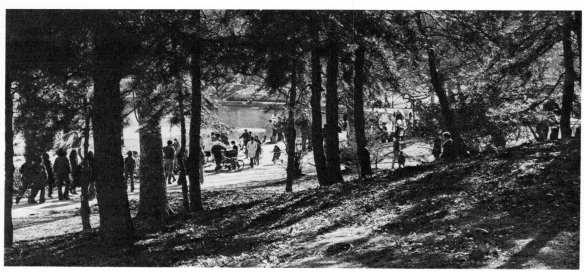

H. WEISS

44

3. The Photo Series

A photo series is a number of photographs taken with one idea or theme in mind. The series may be only three or four pictures—or ten, or fifty. It is a group of photographs which examines and explores one particular idea.

On the opposite page is a photo series consisting of six photographs. The theme is simply "Sunday in the Park." It shows the sort of thing that goes on in a park on a sunny afternoon. There is no sequence or story. But there is a certain unity and interest because there is a single idea.

On pages six and seven there is another series of eight small photographs which the author took to demonstrate the kind of subject matter one finds along any city street. Although the pictures, individually, are not very dramatic, they convey the feeling of activity and variety that can be found on any busy thoroughfare when grouped together. If you look carefully you can see that a young fellow in a dark shirt, the author's son, appears in every one of the photographs. This was a device used to give the series additional continuity.

On the following two pages are two somewhat more ambitious picture series. In one, the theme is "Circles," and several days were spent wandering around with friends looking for and photographing anything that was circular. This was great fun and every time a circular object was found there was much excitement and discussion of its suitability.

The picture series on signs was simply an effort to find as many different kinds of signs as possible. Any single sign by itself would be rather uninteresting. But the variety and contrast of the group of seven photographs is something quite different. The result is more than the sum of the parts.

The ideas of "Circles," "Signs," and "Sunday in the Park" are rather obvious and simple notions. But it is not really necessary to have a terribly important or profound theme. Just the fact that there is some kind of purpose or continuity makes a series interesting and meaningful.

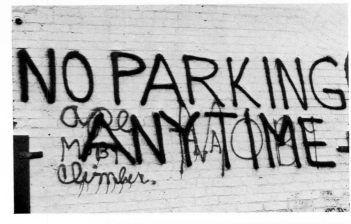

SIGNS

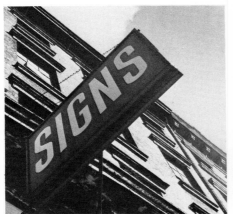

CIRCLES

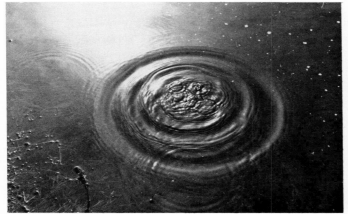

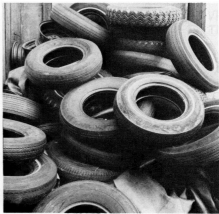

H. WEISS

H. WEISS

JOHN R. KENNEDY

The Picture Assignment

There are several good reasons why you should spend some time and film on photo series. Very often the amateur photographer will wander off on a sunny day, his camera loaded, a spare roll or two of film in his pocket, ready to take some photographic masterpieces. But he will have no destination, no purpose. And often the result will be a very miscellaneous bunch of snapshots with little connection, reason, or point of view. If you give yourself a "picture

48

assignment" your attitude is different. You feel you have a purpose and reason for what you are doing. It is more fun and more productive. (The fact that you thought of a theme does not mean you can't change your mind if you get a better idea along the way. Nor does it mean that you have to ignore an especially promising shot that doesn't fit your theme.) Even the less successful pictures you get will have an additional interest and value because they fit into a larger scheme of things and contribute to the overall effect.

There are a few things you should consider before you set out on a photographic expedition. You should try to find a theme that will be suitable for the kind of camera you have. If you have a simple camera with a single, fixed-speed shutter you might, for example, have some trouble doing a series on race horses in motion.

You should also try to find a theme that will not require too much trouble locating the necessary subjects. If you live in the country it would be easier to do a series on trees, farm animals, or barns rather than one on rush-hour traffic or the city skyline.

Here are a number of possibilities for photographic series which you might find interesting, or which may suggest other ideas to you: doors, pets, signs and bill-boards, a rainy day, houses, kinds of trucks, textures, clouds, patterns of light and dark, squares, hats, stores, a football or baseball game, different trades and professions, and so on.

Photo series lend themselves particularly well to display in little folders or booklets of the sort described at the end of this chapter.

The Picture Story

A picture story is quite similar to the photo series already discussed. The main difference is that the picture story is concerned with an event or sequence of events. There is a beginning and an end. In other words, it is more of a *story*.

When you and your friends, or family, get out and go somewhere or do something you usually have the

makings of a picture story. A picnic, a visit to a place of interest, a day at the beach, or just an afternoon stroll are the kinds of situations that can easily be made into a picture story. (It doesn't have to be a major event, like a trip to the Grand Canyon or the birth of a litter of kittens.)

How do you manage to get a good picture story? You do it by giving a little thought beforehand to what is going to happen. Sometimes, with a lot of action going on and a variety of things happening, there is too much confusion for you to figure out in a hurry what should be photographed.

Because a picture story is not like a movie, which records all the action in a continuous stream, you must pick out the individual actions or events which best tell what is happening. Just a few written notes, listing some of the shots you plan to take, will be a very handy guide. Below is the sort of list you might make for a picture story of "A Day on Skis."

1. We put the skis on the car.
2. Carrying the skis to the slope.
3. Putting them on.
4. Getting on the lift.
5. Top of the hill.
6. Coming down.
7. Falling.
8. Lunch.
9. More falling.
10. Going home.

All these shots would be quite obvious. There's nothing very unusual here; yet, without general preplanning, you might very easily overlook some key episode. Doubtless there will be other unexpected events that will occur during the day which will round out the story.

Picture stories are usually readable from the pictures themselves. But sometimes a brief written explanation or caption is necessary. Be sure your pictures are in the right sequence when you mount your prints into a folder or booklet as shown on page 53.

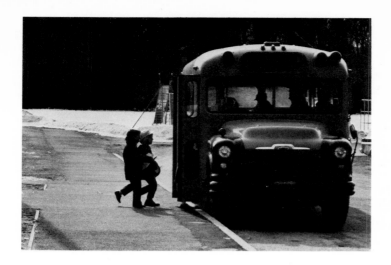

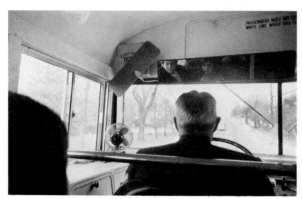

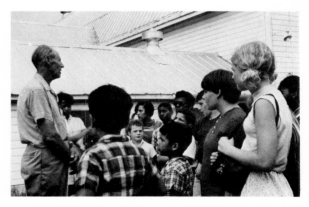

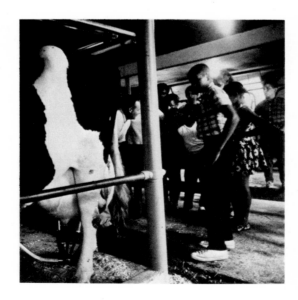

HENRY HUMPHREY. This little picture story describes a school visit to a dairy.

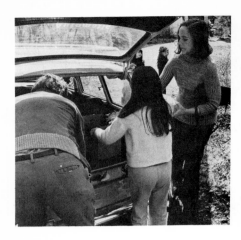

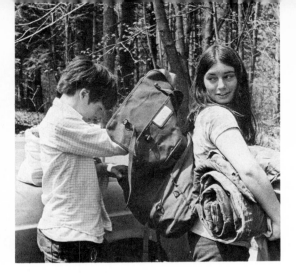

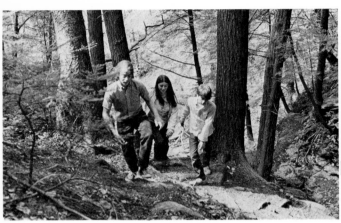

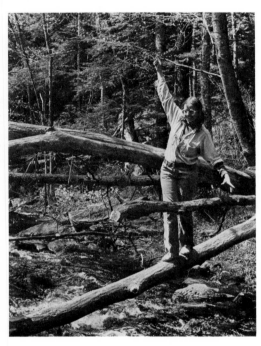

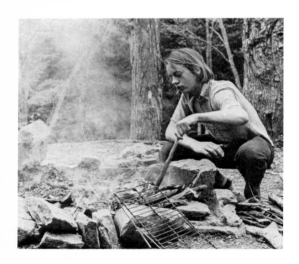

H. WEISS. A picnic or camping trip provides a variety of activities that can make an interesting picture story.

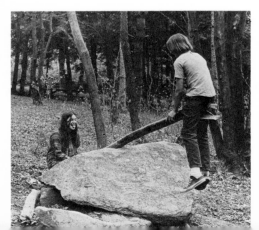

A Booklet or Folder for Photographs

The secret of making a good-looking booklet or folder is the paper you use. Even the best photographs will look shabby unless you manage to get some nice, heavy paper. If the paper is too thin it will buckle when you paste down the photographs. Avoid thin typewriter paper or flimsy drawing paper. Any art or stationery store will have a selection of paper in various colors which is quite suitable.

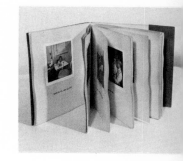

Choose a booklet or folder size which you can cut out of your larger sheet of paper without too much waste. When you paste down your prints don't use too much glue or you will get buckling. A little dab of a white casein glue, like Elmer's Glue, on each corner of your print should be enough to hold it securely. If you have many small pages in your booklet sew them together as shown in the drawing below. This can make a very nice professional-looking booklet. Sometimes the photographs look better if you carefully cut away the white borders that surround them. Captions look best if you type them the same width as the print on a separate piece of paper and then glue them in the booklet.

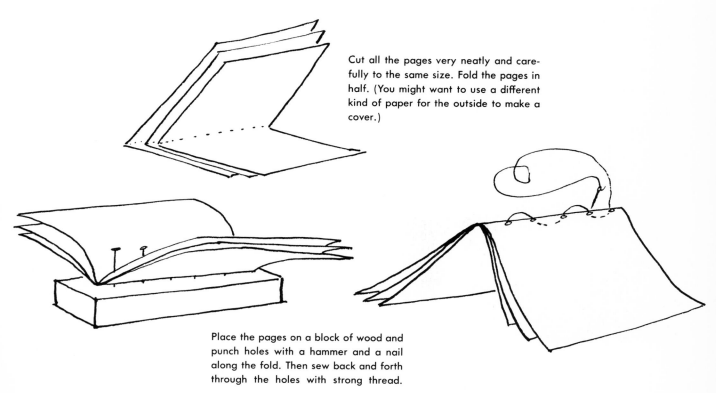

Cut all the pages very neatly and carefully to the same size. Fold the pages in half. (You might want to use a different kind of paper for the outside to make a cover.)

Place the pages on a block of wood and punch holes with a hammer and a nail along the fold. Then sew back and forth through the holes with strong thread.

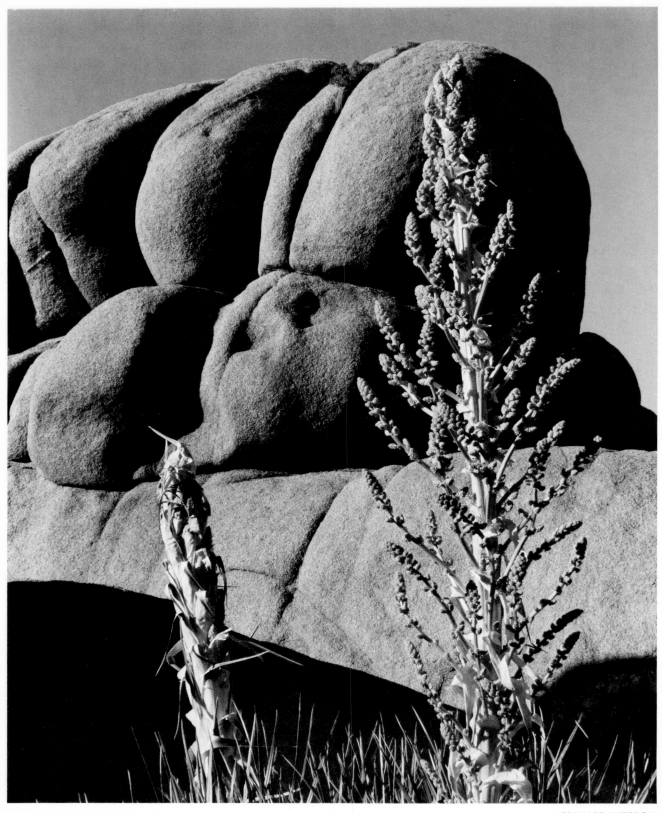

EDWARD WESTON

54

4. The Art of Photography

Ever since the invention of photography there have been arguments between painters and photographers about whether photography is an art. The painters claim that a photograph is simply a copy of something that already exists; therefore, no creative ability is involved.

The photographers reply that they must select, interpret, and by means of their own ideas and feelings make something personal and unique. They compare themselves to a sculptor carving a block of marble. The sculptor didn't make the marble. It already existed. But the sculptor must decide what to do with it; what part of the stone to leave untouched—what part of the whole rough block to single out and carefully delineate and polish. The "block of marble" for the photographer is the world around him with its infinite images.

The answer to the argument is probably yes and no. When a camera is simply pointed at an object and the shutter clicked without much thought or care, the result will be a simple copy of what the camera was "looking at." But it would be hard to look at most of the photographs reproduced in this book and say that they weren't more than a simple record of a person or place.

In the picture by Edward Weston on the opposite page there is much artistic judgment. The subject matter is a pile of rocks, some grass, and a rather ordinary-looking plant. The angle and position of the camera was very carefully chosen. Notice how the light on the plant makes

it stand out against the deep shadow of the rock. The photographer waited until the sun cast exactly the kind of shadow he wanted. The picture is "framed" so that there is a thin edge of grass along the bottom to provide a little variety of texture. There is just enough sky included to set off the shape of the rocks. There is an interesting variety of lights and darks. This is typical of the beautifully composed pictures of Edward Weston, who is one of America's most famous and respected photographers.

You may say all the objects in this picture actually existed before the photographer ever appeared. They did. But no one ever *saw* them exactly the way our photographer did. Weston's view of this scene and his technical experience and ability to capture it are what make this photograph a beautiful and unique thing.

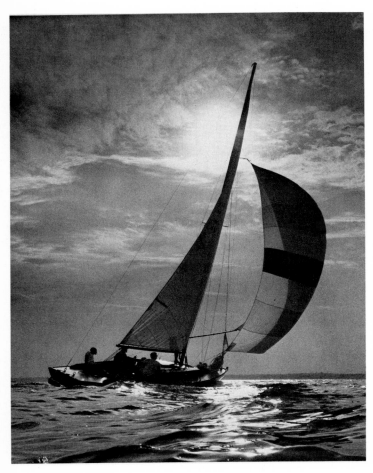

PETER BARLOW

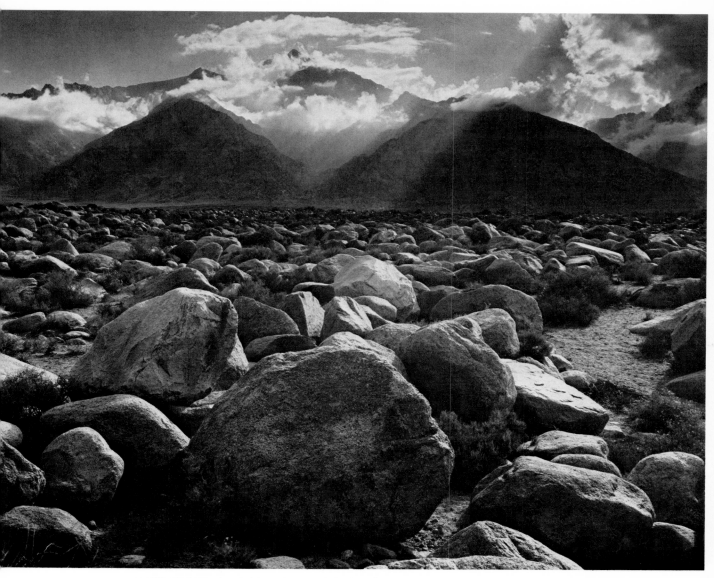

ANSEL ADAMS. Ansel Adams is one of the best known American photographers. He uses a large camera which enables him to make prints with the greatest crispness and detail. He is a perfectionist who will spend hours, or even days waiting for exactly the right light conditions for a single photograph. This view of Mount Williamson in California is one of his most famous.

Some Basic Principles

There are certain basic art principles which every photographer should be aware of. They apply to most art forms, and they apply to photography. These are not rules which the photographer must follow. Rather, they are hints, or suggestions—and you'll find that they are ignored as often as they are followed.

1. There should be a *reason* for taking a picture, and this reason should be apparent in the finished print. It may be that you like the shape of a tree or the expression on a face. You may be attracted by the pattern of cobblestones in a street, or the sense of emptiness in a landscape, or the happiness in a little girl dancing. Concentrate on whatever interests you, so that your idea will be communicated to the person who will be looking at your picture. Knowing your reason for taking a picture will keep you from getting vague, cluttered photographs with no purpose or center of interest.

Sometimes, of course, you may not be able to put into words just why you want to take a picture. You just *know* that you do. You might call this "artist's intuition," and it is a very good reason indeed for going ahead and clicking the shutter.

2. Learn to be aware of light. The quality of light is very much a photographer's concern. You must look at the shadows it produces, or the quality of softness or harshness, and decide just what it is you want. Sometimes a very ordinary scene will take on a great interest because of the light.

ANTONIO A. FERNANDEZ

58

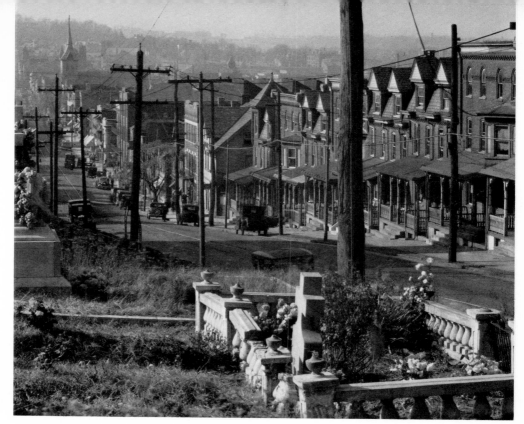

WALKER EVANS. This photograph was taken over thirty-five years ago, as some of the old-fashioned automobiles would indicate. But it is just as interesting today. The depth and clarity, the contrast between the houses and the tombstones, the sense of reality, all serve to make this a memorable photograph.

3. Try to have something in the foreground as well as the background. This is particularly true with landscapes or distant views.

HENRY HUMPHREY

RON MESAROS. In this photograph as well as the one below and on the facing page, the element of contrast is of major importance and provides the dramatic interest.

60

JOHN VACHON

4. Avoid too symmetrical a composition. For example, try not to have a horizon line dividing a picture into two even halves. Having your center of interest exactly centered is usually rather dull.

5. Look for *contrasts*. There are all kinds and they often are the basis for effective photography. There is the contrast of light and dark; the contrast of something old with something new; something big with something little; beautiful with ugly; near with far; good with bad; rural with urban; rough with smooth, and so on. When you have opposites such as these in one photograph you immediately have a dramatic situation and a picture which is saying something.

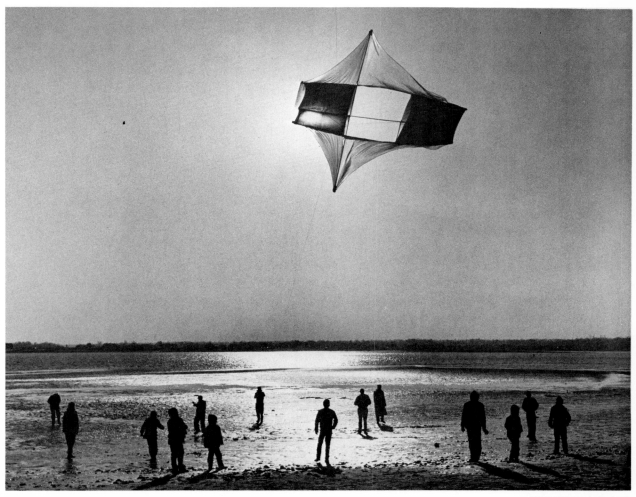

GEORGE CARDOZO

6. Look for the rhythms and patterns that exist everywhere. At times, think of your subject not as a person or landscape or object, but as a *design* made up of light and dark areas of various shapes, textures, volumes.

7. Come to your own conclusions. There is the temptation for the beginning photographer to try to take photographs just like those he has seen somewhere and liked. That's all right, but don't stop there. Look for the sort of subject matter that appeals particularly to you. If you like bridges, for example, go out and look for them and then shoot them in as many different ways as you can think of. If you like lots of contrasting black and white shapes in your pictures, keep an eye open for that sort of subject. In other words, do "your own thing."

There are many different attitudes about photography. Not everybody is concerned with the photograph as an object of beauty. Some people—news photographers, for example—care mostly about what is happening, and its value as a story or dramatic moment. Others think of the camera simply as a record-keeping machine. And there are many other points of view. But in all cases the picture can be improved and will do its job better if the photographer is aware of the artistic principles discussed here.

FENTON T. BENTON

HELENE RYDSTROM

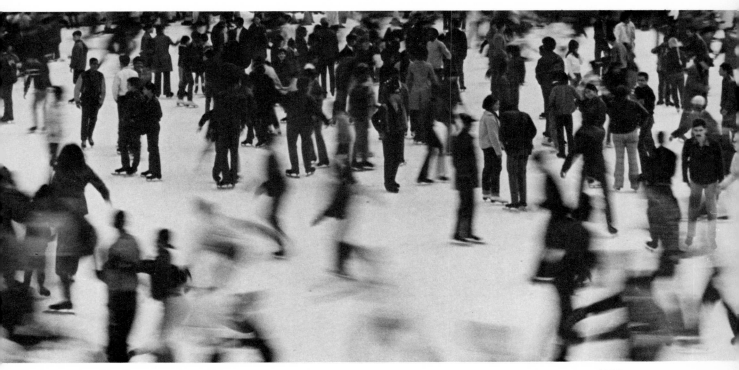

ALAIN JAHAN

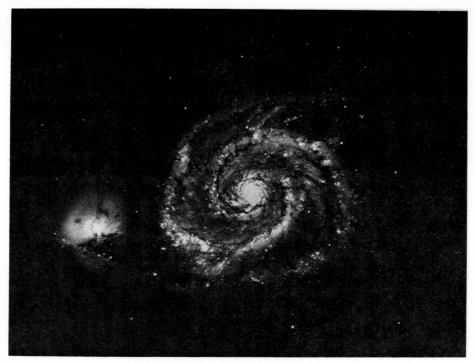

PALOMAR OBSERVATORY PHOTOGRAPH: A spiral nebula.

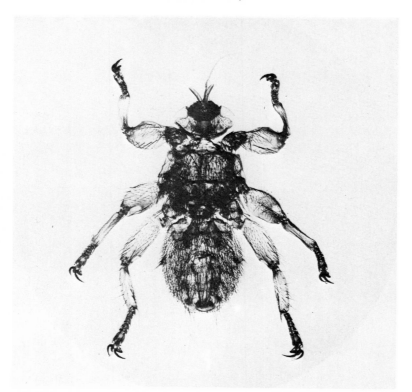

AMERICAN MUSEUM OF NATURAL HISTORY. The body of this common house fly was treated with special solutions in order to make the tissue semi-transparent. Then it was lighted from behind and photographed with a close-up attachment on the camera.

5. The Camera and Science

The camera is a tool that scientists in many fields find indispensable to their work. A camera is able to record objects, events, or phenomena that cannot be seen by the human eye. Maybe the action is too swift. Perhaps the eye is not sensitive enough. For example, the astronomer attaches a camera to his telescope and allows the film to remain trained on one spot in the sky for minutes or hours. The film will record detail that the human eye could never begin to capture. Most kinds of scientific photography require very special equipment such as high-speed stroboscopic lights, microscopes, specialized lenses and cameras and apparatus you are not likely to have.

But the camera is also used in more ordinary ways for scientific purposes. Often it is used to record a scene or an event so that it can later be referred to, and be at hand when needed. Geologists will photograph hills, mountains, cliffs, rock formations and then at their leisure study the information contained in the prints. They can compare photographs of a glacial moraine found in Alaska with those of a glacier in the Andean mountains at the same time.

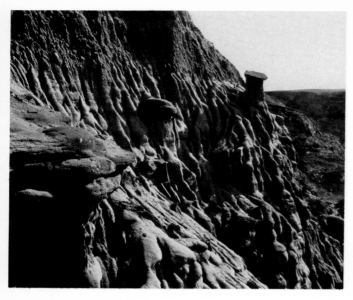

AMERICAN MUSEUM OF NATURAL HISTORY. A picture of the erosion of a hillside can tell a great deal about the geological nature of a particular area.

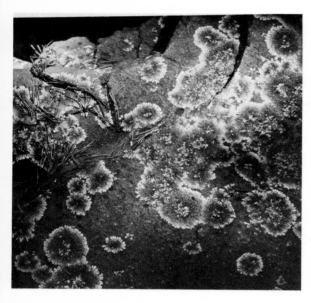

JOHN R. KENNEDY. Lichen on a rock—or, if botany is your particular interest you would describe this as *epiphytic ascomycetous.*

Some Science and Nature Photography You Can Do

A series of step-by-step photographs will often demonstrate and explain some interesting scientific facts. For example, you could show the growth and development of a river. You could start with the beginnings of a little creek, follow it to a larger creek, into a stream, to a river, to a larger river, and perhaps to the sea.

Some other possibilities are the change in foliage through the seasons, the construction of a highway or

GEORGE CARDOZO

building, the step-by-step construction of a model or carpentry project, and so on.

It is also possible, of course, to take photographs of all sorts of things which are of scientific interest in themselves. You might want to show how a tree can split a rock apart, or what different forms lightning takes. You can get the lightning picture by setting your camera on time exposure some night when there is an electrical storm. Open the window. Set your camera on a tripod or on some solid support such as a table. If you leave the shutter open for ten or fifteen minutes when the lightning is active you should get a good variety of patterns. (You might want to try this technique with fireworks or with your camera

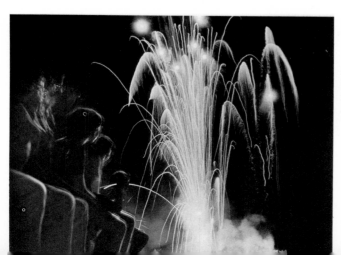

JON SINISH. This was about a five- or ten-second exposure. You can see the blurred image when the boy on the left moved while the shutter was open.

67

pointed at a road. The headlights from the cars will make all sorts of lines and swirls.)

Sometimes just a photographic record of different kinds of rocks or plant forms or birds can be used as part of a science project. For example, you could do a scientific essay on tree forms, and show with photographs the kinds of limbs and trunks different trees have. You could do a series on clouds, land erosion, wild flowers, snow patterns, swamp plants, farm machinery.

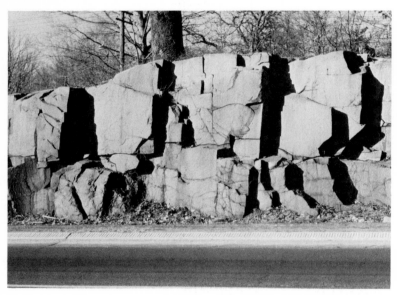

AMERICAN MUSEUM OF NATURAL HISTORY

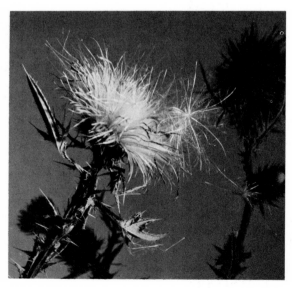

H. WEISS

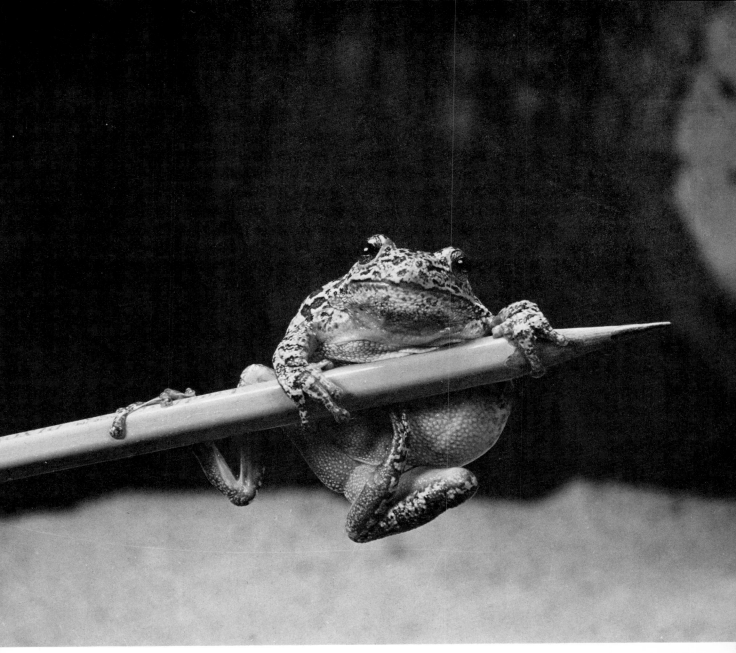

Close-ups

A good deal of scientific photography is involved with close-ups. Details of insects, flowers, coins, stamps, and plants require extreme magnification. And this gets a little complicated. There are special attachments, called supplementary lenses, which can be fitted over your regular lens. With these in place you can get very close to your subject—how close depends on the kind of supplementary lens you get.

When you get very close the question of focus also becomes important. With a close-up lens the depth of field becomes quite narrow. If you have a single-lens reflex of the sort described on page 11 you can look right through the lens and see when you are in focus. With a viewfinder-type camera you must carefully measure the distance from lens to subject, following the directions that come with the close-up lens.

When you take a close-up and produce a large image of something you are used to seeing small, the object takes on a different character. The most ordinary thing will often become quite striking and at times quite beautiful.

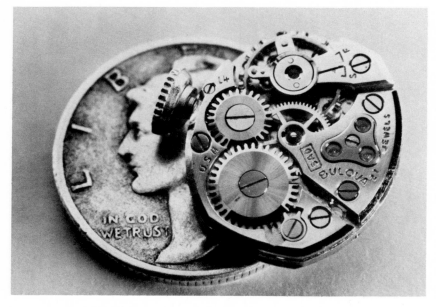

MARTIN IGER

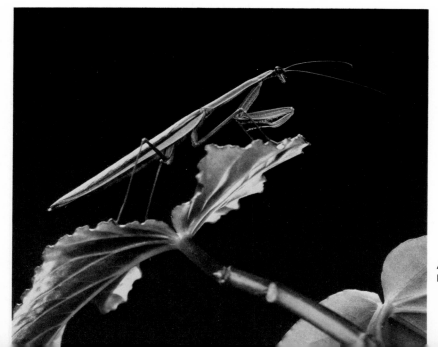

70

AMERICAN MUSEUM OF
NATURAL HISTORY

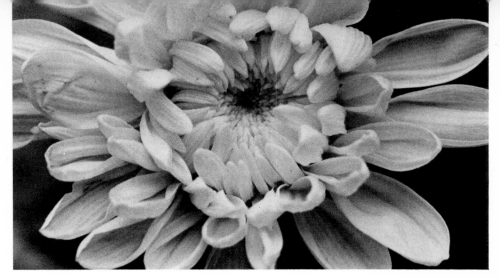

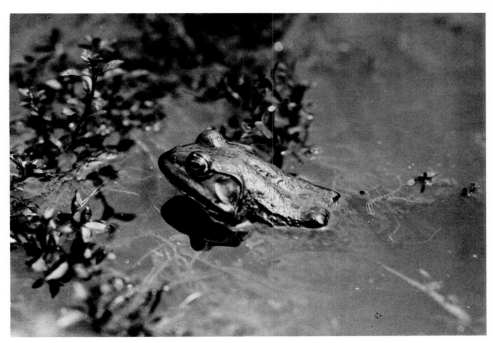

FRANK OVERTON, American Museum of Natural History. It is always a bit of a gamble to see how close you can get to an animal before he takes off.

Below, AMERICAN MUSEUM OF NATURAL HISTORY. Naturalists who take close-ups of live insects will sometimes put them in the refrigerator for a while before taking the photograph. This will keep them from being too active while their picture is being taken.

Animal and Bird Photography

Photography of wild animals and birds is another kind of scientific project that is tricky, but very satisfying when successful. Today there are big-game hunters who will travel all over the world in order to shoot wild animals—with film, rather than bullets. In fact, there are photographic safaris, complete with white hunter and porters, that travel into the wildest parts of Africa for just this purpose.

You can't get very close to birds or wild animals without scaring them away. So one method often used is to set up a camera where you expect (and hope) your subject will be. Then, by some means, click the shutter from a distance. The well-known nature photographer, Russ Kinne, has used the gadget shown below. It is an easily made remote-control device that will trip the shutter of your camera when a thread is pulled. All you need is a mousetrap and a cable release. The cable release, which is available from any camera store for about a dollar, is a flexible, narrow "pipe," inside of which is a cable. This is screwed into a cable release socket in your camera. You press one end of this cable and the other end pops out, tripping the shutter mechanism in your camera. (Make sure your camera has a socket for the cable release. Many simple, inexpensive cameras don't.)

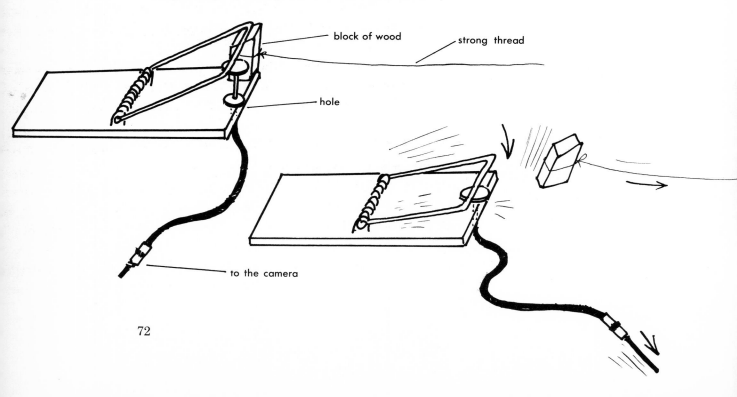

block of wood strong thread

hole

to the camera

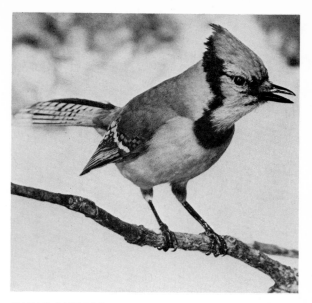

MARY C. DICKERSON, American Museum of Natural History. Many of the pictures that are taken by nature photographers are possible only because a telephoto lens is used.

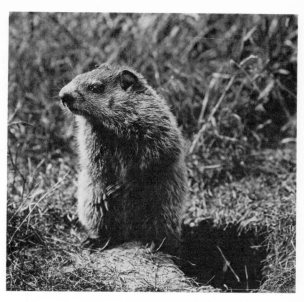

AMERICAN MUSEUM OF NATURAL HISTORY. A woodchuck sitting beside his hole.

JOHN R. KENNEDY. To get pictures of wild animals like this, you don't need any remote control devices. All you need is enough light, and patience to wait for an interesting pose.

The string which sets off the mousetrap can be quite long. And you can hide indoors or behind a bush quite a distance off, waiting for the action you want to photograph.

The camera must be mounted securely, preferably on a tripod, and you must have enough light. (For night pictures you can use flash, described on page 88.) If you have a feeding place for birds you should be able to set your camera up close by—perhaps with a close-up attachment on the lens—and get some action without too long a wait.

It is also possible to tie the remote-control thread to some bait. When the bait is picked up by a squirrel, deer, raccoon, bear, etc., the shutter is tripped, and you have your picture. Another possibility is to stretch the thread across a trail in the woods that is used by wild animals.

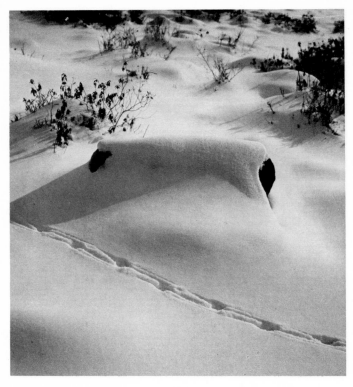

MARY C. DICKERSON, American Museum
of Natural History. The tracks of a crow.

In the winter time, if you can't find any animals to "shoot," you might settle for some photographs of the animal tracks which are seen everywhere in the snow. In the early morning or late afternoon, when the sun is low, the shadows in the tracks make them show up quite clearly.

Another very specialized kind of nature photography is done underwater. Conventional cameras are used for this kind of picture-taking. But the camera is enclosed in a waterproof box with a glass window in front of the lens, and there are special controls for focusing and adjusting diaphragm and shutter.

If you don't have the rather elaborate equipment needed for underwater photography—and not many people do—you can settle for taking pictures of the fish in a fish bowl or an aquarium. If you can get enough light on the aquarium (without light reflecting off the glass) and if you can position your camera close enough and wait for the right moment, you should be able to get some fine results.

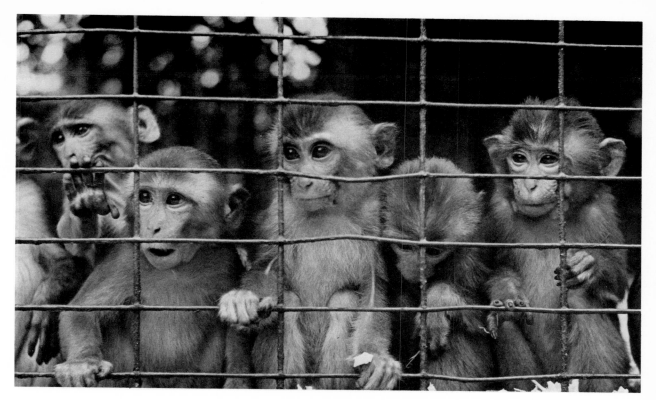

JOHN R. KENNEDY

JOHN R. KENNEDY

The zoo is, of course, the easiest place to find a variety of animals. The light is usually poor inside, but if you can get the animals in the outside areas or in their outside cages you should be able to get results like these.

NEW YORK ZOOLOGICAL SOCIETY

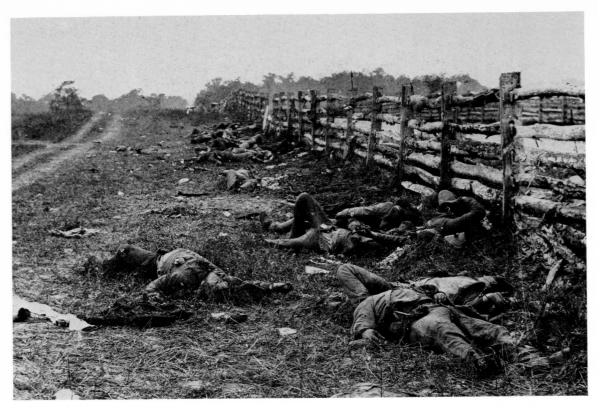

ALEXANDER GARDNER, the Mathew Brady collection, Library of Congress. This photograph is entitled, "View of the dead on the west side of Hagerstown Pike, Antietam, Maryland, September, 1862." Antietam is a little village in Maryland where some of the fiercest fighting of the Civil War took place.

Below, LEWIS W. HINE. A young girl working in a South Carolina cotton mill. This photograph was taken in 1908.

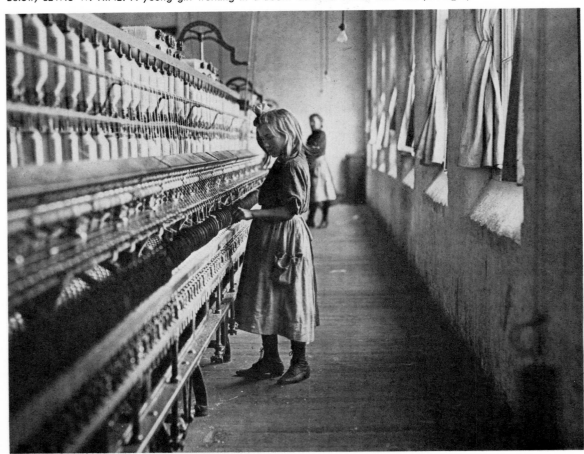

6. Ideas and Opinions with the Camera

One of the things a photograph does supremely well is show the truth. When you look at the photograph on the opposite page of a Civil War battlefield you know that is exactly how this battlefield looked. It was a barren, muddy, and desolate place. No one is alive today who saw that field, and the only visual record we have about it is from photographs like this one by Alexander Gardner.

Because photographs show the way things are, they are often indisputable evidence in an argument. (There are some circumstances where a photograph can distort the truth because of tricky angles or darkroom manipulation, but this is rather uncommon.) There are cases where photographs have in very dramatic ways changed the course of history.

For example, in the early 1900's a photographer and sociologist, Lewis W. Hine, took many pictures of very young children working in factories. The photographs were widely published and aroused much indignation. They led to the passing of child labor laws.

Another case was a series of photographs of what is now Yellowstone National Park. The photographs were shown to the United States Congress and led to government acquisition of the land which is now the national park.

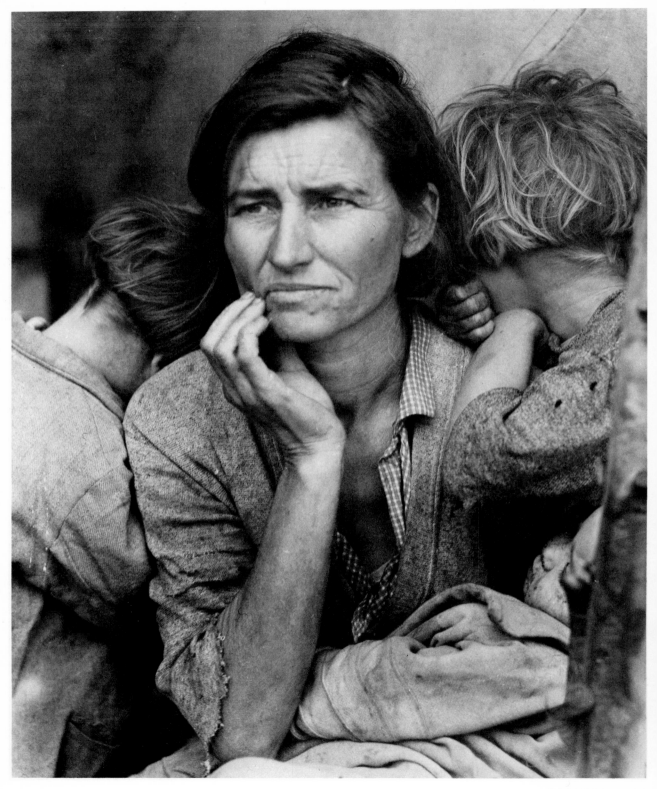

DOROTHEA LANGE

The photograph on the opposite page by Dorothea Lange was made in 1936 as part of a government project. Its purpose was to record the experiences of migrant farm workers and their families—their work, where they lived, and how they endured an extremely difficult and impoverished way of life. Many of the photographs were published in books and magazines. They were seen by millions of people and helped to create an awareness of the plight of these people.

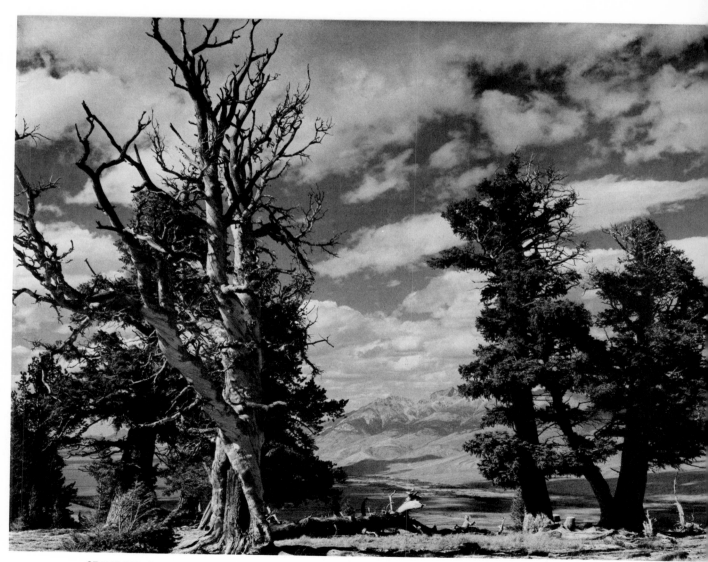

STANDARD OIL COMPANY (N. J.). Sometimes, just showing the beauties of unspoiled, seldom-visited country will suggest the need for preservation and intelligent management of natural resources.

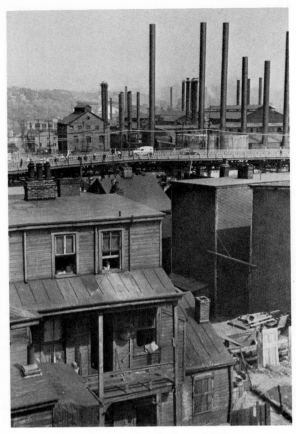

ARTHUR ROTHSTEIN. Pittsburgh slums, 1938.

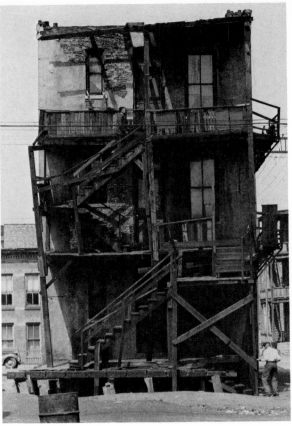

RUSSELL LEE. A multi-family dwelling in Chicago, 1941. This photograph and the one on the left were taken in an effort to get improved housing for residents of big city slums.

Today there are many ways you can make your feelings and opinions known to other people by means of photography. For example, suppose you found that the garbage pickups were inadequate where you live. How could you and your camera do something about it? You could take some photographs of overflowing trash cans, litter on the streets, perhaps a dog or cat foraging among all this. Your photographs, along with a letter to the department of health or the mayor, would probably produce results.

Or suppose you found a factory smokestack that continually poured out black clouds of dangerous-looking smoke. A photograph of this situation along with a note to the proper authorities would undoubtedly cause some sort of action. There are many similar situations where the evidence of a photograph will help you accomplish something.

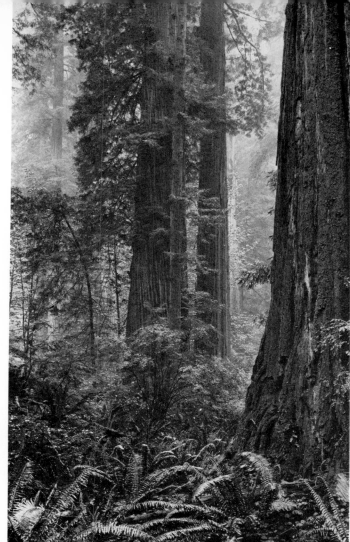

The picture on the right was made for an organization called the Save-The-Redwoods League. The sole purpose of this group is to fight to keep the magnificent west coast redwood forests from being cut down by developers and lumber companies.

DOUG YULE

Pictures such as the two below are undeniable evidence of the sort of small-scale pollution often encountered.

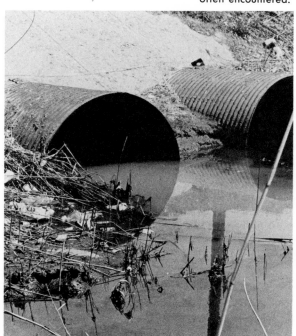

FENTON T. BENTON

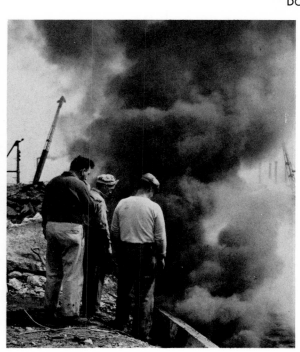

JOHN R. KENNEDY

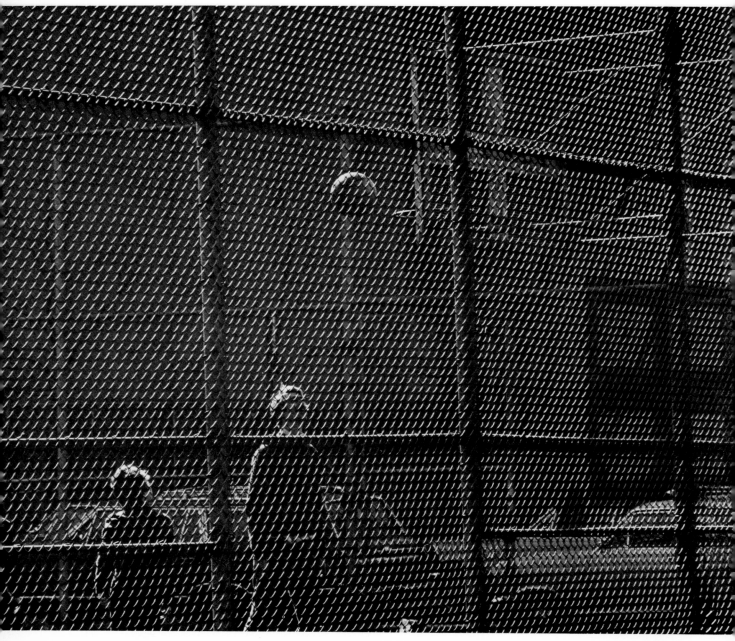

HELENE RYDSTROM

7. Light and Artificial Light

Light is one of the tools of the photographer. It is just as indispensable as the camera or the film. As a photographer you must be aware of the many different kinds of light—the soft, gray light of a foggy or overcast day, the light of a sunset, or the bright, harsh light of a noonday sun, the light reflected from sand or water or from a white wall. There are many kinds of natural light, and many ways of using it.

The illustrations on the next few pages show how the photographer has used the quality of light as the major element in the picture. In most cases the subject matter is quite unextraordinary. There is nothing very unusual about the wire mesh fence around a schoolyard, or a smoky fire under some trees. What is unusual is the way the light can transform such ordinary subjects into something quite striking and beautiful.

JON SINISH

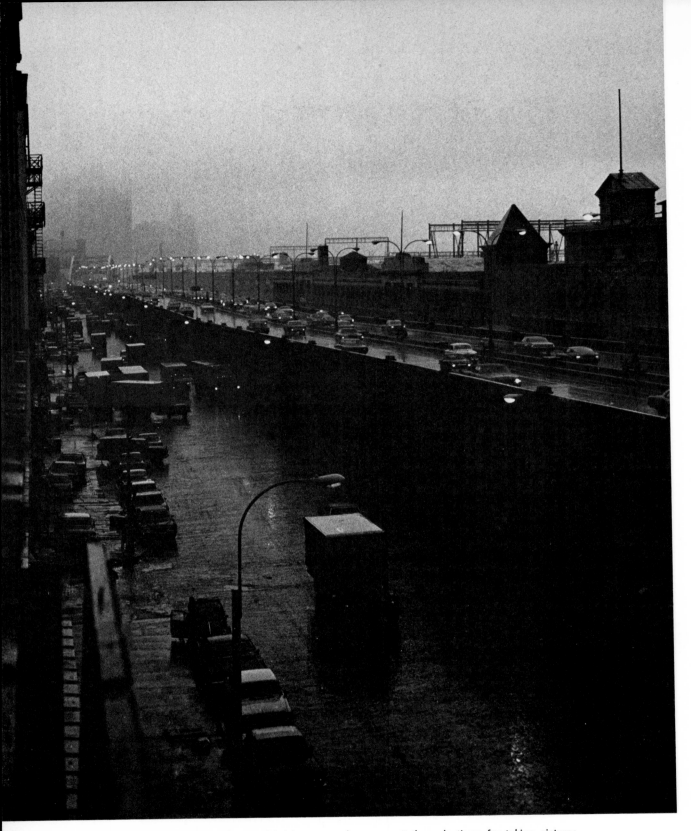

PHILIP GUDWIN. Clear skies and bright, sunny days are not the only times for taking pictures. This photograph was taken at twilight. The street lights are already on and the mood of a cold and cheerless evening is very apparent.

GEORGE CARDOZO. This is certainly an unusual source of light.

FENTON T. BENTON. The pattern of strong, contrasty shadows can make even a very plain street scene like this quite dramatic.

There is not much you can do about natural light except, perhaps, to wait for it to appear the way you want it. (Photographers do a lot of waiting—waiting for the sun to come out, or a cloud to move, or a subject to smile, or a dog to stop scratching . . .) But artificial light can be controlled by you. You can put it where, when, and how you want it. And artificial light is essential if you don't have an obliging sun. At night or indoors the only way you can take pictures is with the light you provide for yourself. There are three main types of indoor lighting.

1. Natural Indoor Lighting

This is light that comes from the lamps or ceiling fixtures that normally illuminate a room. This kind of light can be suitable for picture-taking if there is enough of it, if you have a camera with a fast lens and if you have a fast film in your camera. In order to know if there is enough light, and to know what exposure settings are needed you'll need an exposure meter. (See Chapter 10.)

This kind of natural indoor lighting is nice to use when possible, because it requires no special equipment, has a natural look, and doesn't make people self-conscious.

You can, of course, use daylight for taking pictures indoors if there are enough windows or open doors through which the light can come. But you must be careful with this kind of photograph. Pictures taken under these conditions have a tendency to be very contrasty—dense, black shadows, and too white highlights—unless you have reflectors or varied lights from other sources which will put some light into the shadow areas.

H. WEISS. The windows on the left provided the light for this picture. With lighting of this sort, the contrast between light and dark is often quite extreme unless some light can somehow be reflected into the shadow side of the face. You would need a light meter to determine the correct exposure with tricky lighting like this.

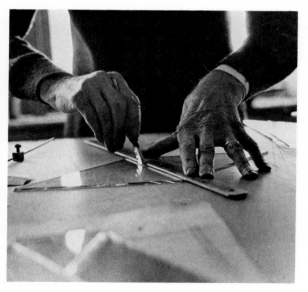

JON SINISH. There was light coming from several different directions here, so there aren't any deep shadows.

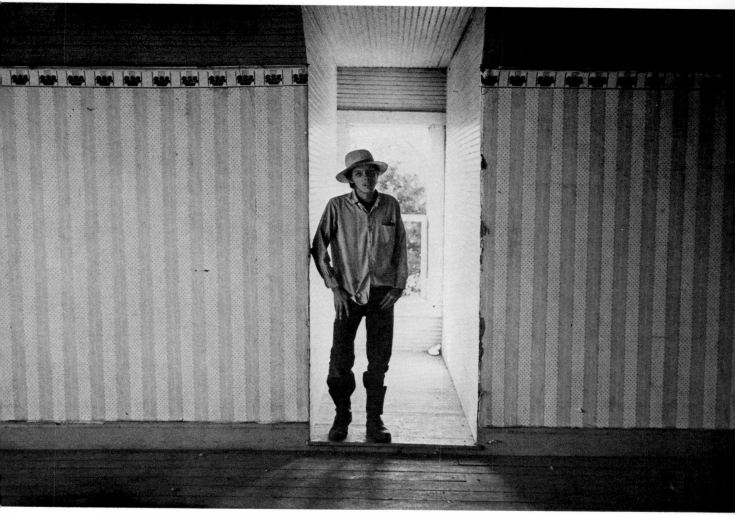

IRWIN KLEIN

H. WEISS. This candid portrait was taken in a museum. The only light came from a large skylight and the spotlights used to illuminate the paintings in the gallery.

JOHN R. KENNEDY. This photograph was taken with a flash. Because the burst of light is concentrated and comes from a bulb close to the camera lens there is a flat, harsh look.

2. Flash

Many of the simple, inexpensive cameras sold today come ready for use with flashcubes. These are small, four-shot flash bulbs which plug right into the camera. Flash works well with color film, but it produces a rather flat, ugly kind of light in black-and-white.

With cameras that have adjustable speeds and diaphragm settings you must consult the directions that come with the flashbulbs or the film to find the right settings. These are determined by the kind of flash you are using and the distance from the camera to the subject. Flash is not good for illuminating large areas—like the circus or a night football game.

There have recently been developed fairly inexpensive electronic flash units which are attached to the camera. The bulb is never changed, and the small batteries used are good for at least two or three hundred flashes. These are sometimes called "strobe" lights, and the flash is strong, but of very short duration—about 1/1000th of a second. This is extremely useful for capturing very fast action. You can find out more about this kind of light from any good camera store.

3. Photoflood

Photofloods are ordinary-looking bulbs which produce a great deal of light. You can get them with a silvered reflecting back. After six hours or so they burn out. But with one or two lights of this kind almost any setting can be well lit. Photofloods are used a great deal for portraits, and one of the usual ways of positioning the lights for this purpose is shown below.

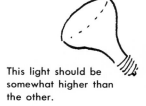

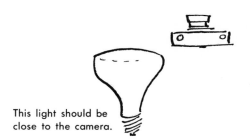

This light should be somewhat higher than the other.

This light should be close to the camera.

H. WEISS. This portrait was taken with the lights arranged as shown in the diagram on the left.

Another excellent way to use photofloods is as a "bounce" light. This means that one or two lights are pointed up toward the ceiling. (It must be a white ceiling.) The light then bounces off the ceiling, producing a soft, diffused light which isn't harsh or theatrical. Some photographers set up a couple of lights like this, and keep them on, while they wander about a room snapping away.

When you use photofloods it is helpful to have a light stand or two. These are collapsible—something like metal music stands—which can be raised very high. They will hold the photofloods in any position you want.

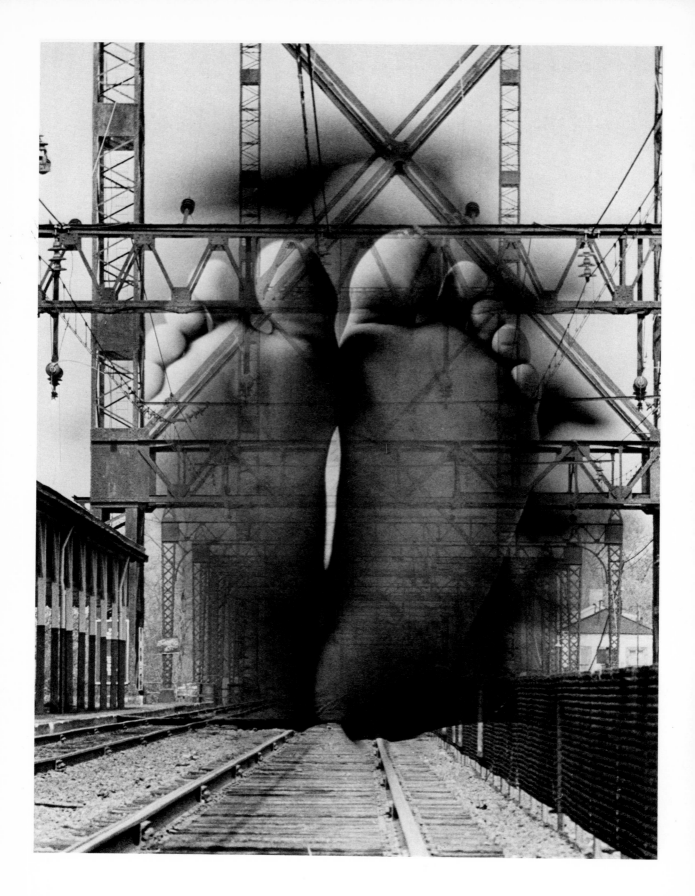

90

JAMES STEVENS

8. Exploring with Photography

Every now and then it is exciting to break away from the usual manner of doing things. It is fun to explore the different ways of using film, to try unusual ideas, different methods, unconventional points of view. Some of the offbeat illustrations on these pages show the kind of experimental photography that can be quite easily tried without any special skills or equipment.

DOUBLE EXPOSURES. A double exposure is usually an accident. It's what happens when you forget to turn the film after clicking the shutter. (Many newer cameras are built so that it is impossible to take a double exposure. You can't click the shutter unless the film has been moved from the previous shot.) However, a double exposure—if you can do it with your camera—and if made for a purpose, can be quite effective.

Opposite, H. WEISS. This double exposure was made in the darkroom when two different negatives were enlarged onto one piece of paper.

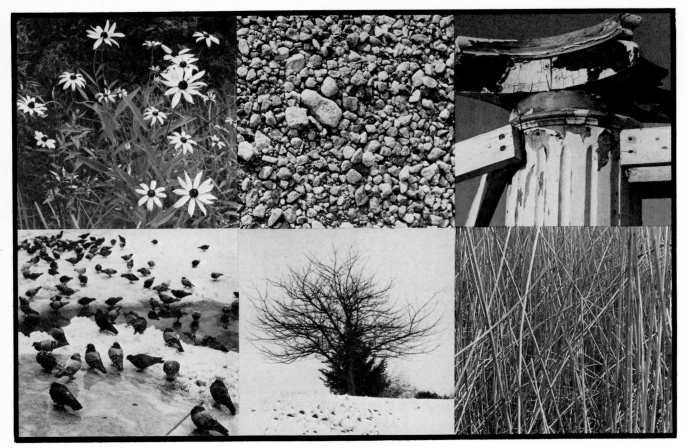

FENTON T. BENTON

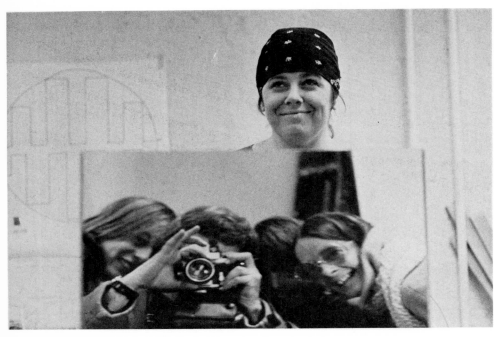

H. WEISS. Reflections from mirrors, water or sometimes plate glass windows can produce double images that are often quite surprising.

92

THE ODD SUBJECT. Some of the photographs reproduced in this section are what you might call "eyeball adventures." There are some strange subjects and unconventional camera angles. Most people wouldn't think of taking many of the pictures shown here. After all, it takes a rather adventurous person with some imagination to decide, "Let's take a picture and see what happens."

CAMERA MOVEMENT. One of the basic rules of good photography is: keep the camera perfectly still when you press the shutter. But any rule can be broken, and if the camera is intentionally moved during the exposure you can often get some very unusual pictures suggestive of speed and motion.

PLACEMENT. If a number of small prints are carefully chosen and thoughtfully grouped, some very interesting results are possible. Each photograph or detail may be quite ordinary by itself, but when grouped together something new and quite different appears. It is possible to assemble prints for the purpose of making a design of textures and tonal values, or it can be done for the sake of dramatic contrasts and comparisons of the subjects.

CUTTING APART. If you have an enlargement of a head or a figure you might want to try cutting it apart and then reassembling it to see what happens.

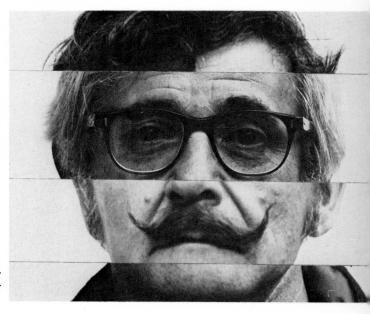

H. WEISS. This rather grim-looking fellow is actually four people and any one of the four is far better looking than the combination.

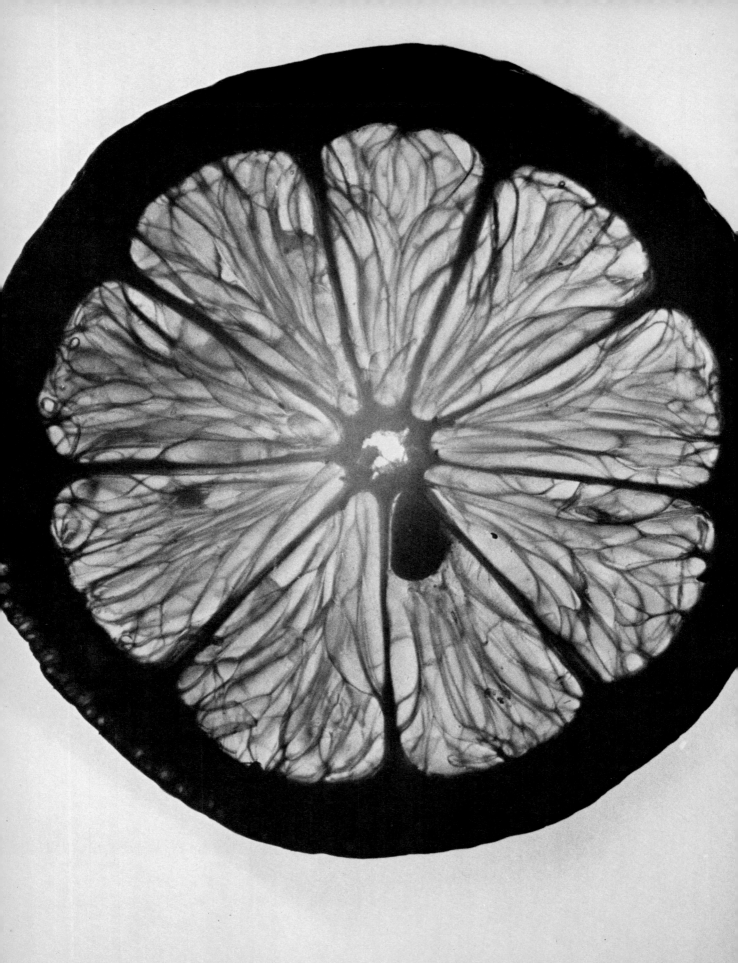

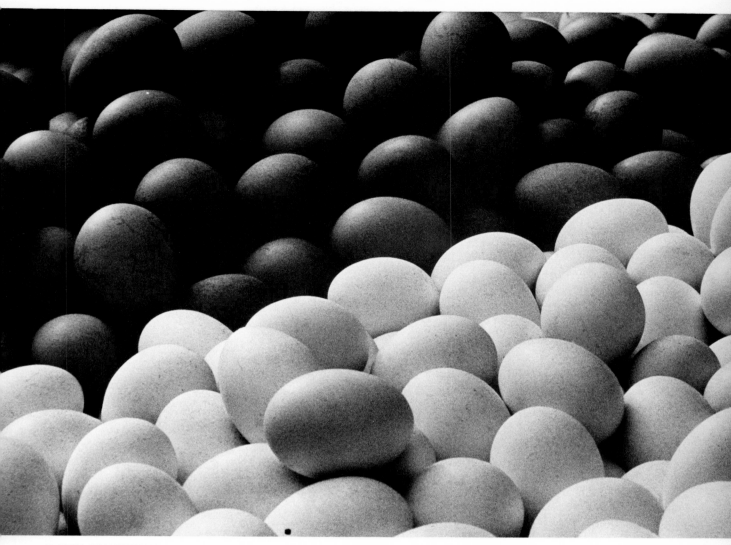

MARCIA KAY KEEGAN

Opposite, HENRY HUMPHREY. This is simply a thin slice of lemon placed on a sheet of glass and lit from behind. The larger-than-life size enlargement helps make it effective.

95

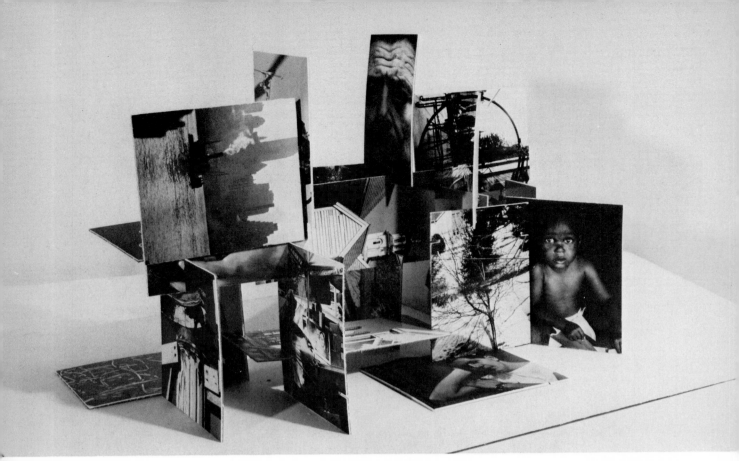

FENTON T. BENTON

MOUNTING. Prints can look quite unusual and provocative when mounted in some of the ways shown here. Prints glued to a smooth, carefully sanded block of wood make a good paperweight, and a fine present.

You can also mount photographs on cardboard the size of a playing card and use them to build constructions or a house of cards. You might also try gluing a lot of prints directly onto a wall to make a mural.

On the opposite page are several suggestions for various out-of-the-ordinary ways of handling photographic prints. The blocks illustrated at the top of the page are two inches square. Portrait heads of six different people have been cut apart and glued onto the blocks—one quarter of each portrait to a block. You'll notice that the heads have been photographed against a white background, and they are all enlarged to the same size so that features can be shifted around and still more or less fit. If you get tired of the way the chin of one of your friends looks, just turn the block on its side and see if you can make an improvement!

96

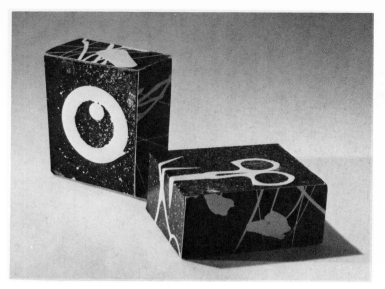

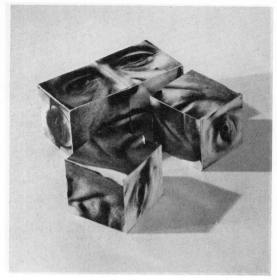

H. WEISS

H. WEISS

97

H. WEISS

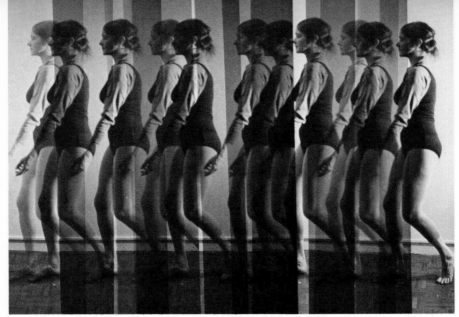

It is possible to make double exposures in the darkroom as well as with the camera. The picture of the "procession" of figures was made in an enlarger using a single negative. The same negative was projected eleven times on a single sheet of enlarging paper. This picture would have been impossibly cluttered if the subject hadn't been in front of a plain white background.

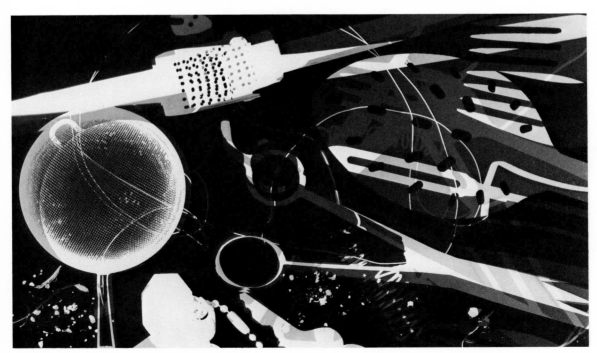

H. WEISS. You can probably identify most of the objects that were used to make this photogram. The white speckles were produced by sand, the thin lines by thread. Some of the shapes are gray rather than pure white because the exposure was interrupted at one point, some of the objects were removed and then the exposure resumed.

98

PHOTOGRAMS. This project and the following one are darkroom projects. If you take a piece of enlarging or contact paper and place some objects on it, then turn on a light briefly, you will get a silhouette image of the objects you used, when the paper is developed. This kind of print is called a *photogram*. If you make several exposures, moving the objects each time you will get a variety of grays and blacks which can be quite handsome.

A somewhat similar technique involves a pane of glass painted black. Scratch a design through the black paint, then contact print the glass as though it were a negative. To get a clear, sharp image make sure the paint is dried, and print with the paint side down. (Contact printing and enlarging are explained in Part Three of this book.)

EXPERIMENTING WITH THE ENLARGER. If you are using an enlarger there are a number of very interesting things you might try. One of the most obvious is to see just how big an enlargement you can get before the grain and loss of detail becomes objectionable. If the enlarger is turned so that it projects onto a piece of enlarging paper on the floor, or on a wall, you can get a huge enlargement. The detail shown below was projected about six feet.

It is also easy to bend or fold your enlarging paper and then project onto it. This will give you the sort of distorted image shown below.

H. WEISS

H. WEISS

9. Color

Most of what we've discussed so far refers to color as well as black-and-white photography. But there are certain disadvantages as well as advantages to color. One of the disadvantages is that the film is somewhat more expensive than black-and-white. Another is that it is fairly tricky to process color film yourself. Color printing and enlarging is not for the beginner. So this whole aspect of photography—which is great fun—is ruled out for the beginner.

But the wonderful thing about color photography is, of course, the *color!* A color slide projected onto a screen in a darkened room can be breathtaking. The brightness and luminosity is astonishing, and the large size of the projected image adds to its dramatic impact. Color prints can also be quite impressive.

Different Kinds of Color Film

There are two main categories of color film. One kind gives you transparencies or slides. The film is returned to you from the processor in the form of individual transparencies mounted in cardboard holders. You can put these slides in a projector and show them, one by one, on a screen. If you want prints, they can also be made from the slides. Some of the films that produce this kind of transparency are: Kodachrome, Ektachrome, Anscochrome, Agfachrome.

The other kind of color film produces a *negative* instead of a slide. And from this negative you can have

enlargements made of any size you want. You can also have slides, suitable for projection, made from this negative. When you hold up a negative like this to the light you'll see mostly orange-reddish colors which make little sense. Kodacolor and Agfacolor are films of this type.

Some of these films are faster than others. (See page 16.) And some are designed for use indoors under artificial light. It is best to get your film at a camera store where you can get advice as to the most suitable type for your purposes. For general use, Kodachrome-X is frequently used.

Color film, like black-and-white film, will have recommended exposure information printed somewhere on the package. If you don't have a great deal of experience with color film, nor a light meter, these recommendations should be followed most carefully.

Using Color

When you use color the temptation is to get as much color into the picture as possible—the more and the brighter the better. But this is often a mistake. You are liable to get garish and rather harsh results. If you can stay more or less in one family of color with a few accents or contrasts the results will be richer—and surprising as it may seem, actually more colorful. There is color in everything, and even the grayest subject can look good on color film.

Because the shape and form of your subject is indicated by color, rather than by shadows, a flat kind of lighting gives more depth and detail than a bright light that casts strong shadows.

The exposures for color film are more critical than for black-and-white film. An overexposed or underexposed black-and-white negative can still produce at least an adequate print, unless the error is too extreme. But color doesn't have this tolerance. You must be careful to get the right exposure or the colors will be seriously distorted. You should carefully follow the exposure directions that come with each roll of film, or use an exposure meter.

10. Some Useful Gadgets

The Exposure Meter

If you use your camera only in normal, well-lit situations, the information that comes with your film is all you need to get perfect exposures. You can get by without an exposure meter. But what happens if the lighting situation is unusual? What happens if you are indoors, or in a hallway, or on a porch or in a thousand different situations where the light is not the simple, outdoor kind? This is when you need an exposure meter.

There are two parts to an exposure meter. One part has a needle that moves along a numbered scale. You read the number at which the needle points. The more light, the higher the reading. Then you go to the second part

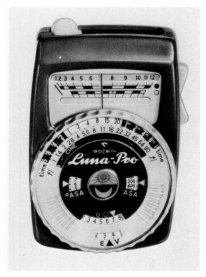

GOSSEN LUNA-PRO. This is a high-quality light meter that will indicate the amount of light under a noon-day sun or indoors in a candle-lit room.

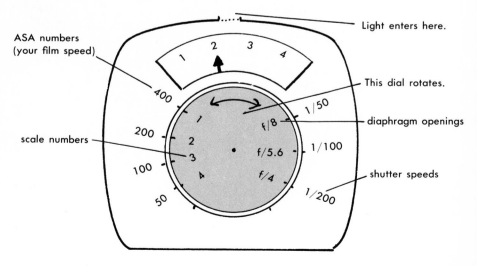

In this simplified diagram, if the needle pointed to 2, and you were using a film with a speed of ASA 200, you would have a choice of these three settings: f/8 at 1/50, or f/5.6 at 1/100, or f/4 at 1/200.

of the meter where there is a rotating dial. You turn this dial until the number you've read is next to the ASA number of the film you are using. That's all there is to it. Now you can look at the other side of the meter dial and choose any combination of shutter speed and diaphragm opening that suits you. Not all exposure meters are arranged exactly as shown in the drawing, but the basic principle is the same.

Tripods

A tripod is a three-legged stand that will support your camera for you. Support is needed for any exposure at speeds slower than 1/50th of a second because it is almost impossible to hold a camera steady in your hands at shutter speeds slower than this. There is bound to be some slight movement which will cause a blurred picture. A tripod is absolutely essential for time exposures. It is generally useful when you want your camera set up and ready to go while you are arranging your subject or waiting until the proper moment to click the shutter. You will also find it very helpful if you do any close-up photography.

Tripods vary from very light, flimsy things to massive steel affairs with many adjustments that can support a heavy studio camera. A tripod that is too light and won't hold the camera perfectly steady is useless, so when choosing one, set it up and test it to make sure it won't wiggle or vibrate.

The most commonly used tripods fold up into a rather compact size, so that you can easily carry one along when you go off on a photographic expedition and think you may be needing it.

Filters

There is one more, quite inexpensive, little piece of equipment you should know about if you plan to use black-and-white film out-of-doors. It is simply a piece of colored glass, called a filter, which slips over the lens. There are various colors, but you'll find the most useful is a medium yellow, which will do wonders for pictures which have an expanse of sky and clouds. The filter darkens the sky.

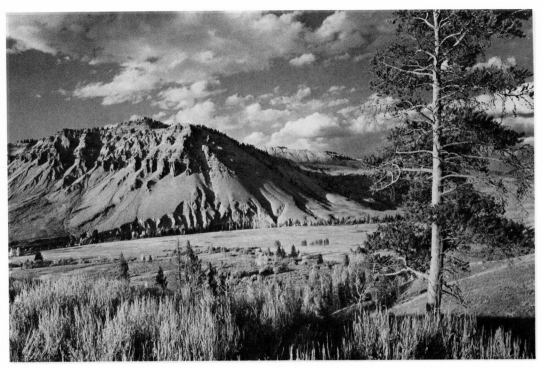

STANDARD OIL COMPANY (N. J.). Because a filter was used here, the clouds stand out in strong contrast against the sky. An orange or red filter was probably used in this picture. This would bring out the clouds more dramatically than the yellow filter and would also lighten anything that is green, such as leaves and grass.

Clouds become much more dramatic. A yellow filter will help you avoid the washed-out, dead-white skies that can spoil many good photographs. A yellow filter will also lighten grass and trees and cut through the haze that often appears in distant landscapes.

A filter slightly cuts down the amount of light that reaches the film. Therefore, the exposure must be increased somewhat when you use one. With a medium yellow filter, for example, the exposure must be doubled. If your proper exposure is f/8 at 1/100, your exposure with the filter should be changed to either f/8 at 1/50, or f/5.6 at 1/100.

There are many other gadgets, special lenses, attachments and what-nots that can be very tempting to the beginning photographer. The camera stores are full of them. But it is the *photographer,* not the equipment, that makes a good picture. It is best really to become familiar with the fundamentals of photography before complicating one's vision with too many distracting non-essentials.

PART THREE
THE DARKROOM

One of the most enjoyable aspects of photography is the work in the darkroom—developing, printing, and enlarging your photographs. Here you first see in permanent form that moment you chose to record when you clicked the shutter. It is enormously exciting to take a piece of photographic paper, expose it under a negative, then put it in a developing solution and watch an image slowly appear on what was blank paper a moment ago.

There are several good reasons why many amateur photographers do their own darkroom work. One of the best is that you don't have to wait around for several days while a photography store sends your pictures out to be processed. You can shoot a roll of film in the afternoon and develop it that same night and see what you have.

Another important reason for doing your own processing is that you get better results this way, once you are familiar with darkroom techniques. This is particularly true of enlarging where a lot of very personal manipulation and control is possible. Another advantage is that it is much cheaper for you to process your own film. Once you have a developing tank and a few other inexpensive items the only additional cost is for chemicals and photographic paper. The only fairly expensive item of equipment in the darkroom is the enlarger. And with a little looking around you may be able to find one you can borrow. A new enlarger will cost from around forty dollars up.

HOW TO DEVELOP FILM

The Steps

The steps in developing your film are: (1) loading the developing tank; (2) developing; (3) stop-bath; (4) fixing with hypo; (5) washing; (6) drying.

The Equipment

This is the equipment you will need:

1. A DARKROOM. This is the first essential. You must be in a completely dark place when you load your film into your processing tank. If any light strikes your film as you are loading it into your tank it will be ruined. A big closet can be used when you load the film into the tank. But when you make contact prints or enlarge you need a little more room and some table space, so you will probably have to work after dark using a kitchen or bathroom—which is what most amateur photographers use. Be sure that no light comes through windows or doors.

2. DEVELOPING TANK. This is a light-tight tank with a lid and a reel inside. It is designed so that you can pour solutions into and out of the tank without any light reaching the film. Putting your film onto the reel is quite tricky and takes some practice, because the film must be handled in total darkness. If you have a roll of film that has already been processed, practice loading it onto the reel many times until you can do it easily with your eyes shut. If you don't have a roll of developed film to practice with it is decidedly worth wasting a fresh roll in order to become familiar with this operation.

3. THERMOMETER. Because the temperature of the solutions you use is quite critical you will need a thermometer. The kind you use to take your own temperature won't do because you have to read in the sixty-seventy degree range. You'll need the kind designed especially for photographic purposes.

4. CLOCK, WATCH, OR TIMER. The length of time your film remains in the developer is quite specific. So you must be able to accurately keep track of it.

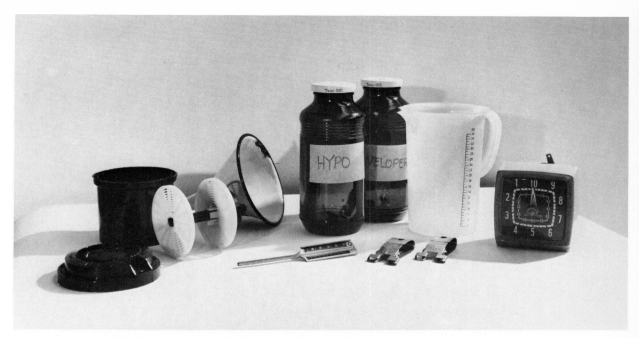

Here is the basic darkroom equipment for developing film. The developing tank with its reel and lid is on the left.

5. FUNNELS. These will make it easier to pour solutions in and out of your developing tank.

6. BOTTLES. To store your various solutions.

7. A GRADUATE. This is a glass or plastic container which has markings along the side which will let you measure quantities of liquid.

The Chemicals

Don't let the words "chemicals" or "solutions" scare you. The chemicals for photography are simply white powders that you pour into water to make solutions. You must very carefully follow the directions on the container, but there are no Dr. Jykell and Mr. Hyde complications to worry about. This is what you'll need:

1. DEVELOPER. This comes as a powder in a can. (There are some more expensive kinds available premixed in liquid form.) The developer used for developing negatives is not the same as the kind used to develop photographic paper. So make sure you get *film* developer. Two popular film developers are Microdol-X and D-76. Instructions for mixing and using the developer will be found on the container.

2. STOP-BATH. This solution is used after the developer. It stops the action of the developer. It is an inexpensive solution and easily prepared, but sometimes it is omitted by photographers who only infrequently develop film. Instead they will rinse the film in running water for two or three minutes. This is perfectly all right.

3. HYPO, OR FIXER. This also comes as a white powder and is mixed with water, following the directions on the container. Hypo dissolves the unexposed silver salts left in the film emulsion so that they can be washed away. It also toughens the film. Once fixed with hypo, the film is not affected by light.

How to Do It

1. LOADING THE TANK. This is done in complete darkness. Kodak Instamatic film and 35mm film must be taken out of the cartridges in which they come. Other films such as 120, 127, 620 come on a spool with a strip of paper backing. The film is attached to the paper by a piece of tape. The strip of paper is removed and discarded before the film is threaded onto the developing tank reel. With the film loaded in the tank and the lid firmly on, you can turn on the light. The rest of the operation can be done with the lights on.

2. DEVELOPING. The method of film-developing in general use is called the time and temperature method. This means that the temperature of the solution must be exactly controlled, and the length of time the film is in the solution must also be precisely regulated. The time and temperature instructions that come with the developer should be followed exactly. (A typical temperature and time for a developer like D-76 used with Tri-X film is seven minutes with the solution at 68 degrees. If the developer were 72 degrees, the developing time would be six minutes.) The temperature of your solution can be controlled by setting the bottle containing the solution in a dishpan of ice-water or hot water, depending on whether you want to raise or lower the temperature.

With the developer at the recommended temperature, note the time, then pour the solution into the tank. While

the developer is in the tank you must agitate it from time to time—about two or three times every minute. Some developing tanks have a little rod which is inserted into the top of the lid. By twisting it, the reel inside is revolved, providing all the agitation needed. Other tanks have to be picked up and rocked gently from side to side. If you don't do this the negatives will come out uneven and streaky. When the recommended developing time is up, pour the developer back into its bottle where it can be stored and used again. Do *not* open the tank!

3. STOP-BATH. Now pour the stop-bath solution into the developing tank. It should be approximately the same temperature as the developer and should remain in the tank for about two minutes. Then pour it back into its bottle. If you use a fresh water rinse instead of the stop-bath be sure its temperature is the same as the developer's. A two- or three-minute rinse is enough.

4. FIXING. Pour the hypo into the tank. Here again the temperature should be approximately the same as the developer's. The hypo should remain in the tank about ten minutes. During this time you should agitate the tank just as you did during the developing. After ten minutes pour the hypo back into its bottle to use again.

5. WASHING. Wash in running water at about 65 to 75 degrees for a half-hour. The washing will be most simple and convenient if you can run a small rubber hose from the faucet to the tank. In some sinks you can place the tank directly under the faucet and let the water just drop into the tank.

6. DRYING. Open the tank. Take the film off the reel. Now you can see the results. Tack one end of the film to the top of a doorway or the edge of a shelf. Fasten a spring clothespin at the bottom. (There are special film clips which you can get at a photography store and clip to top and bottom of the film.) Wipe both sides of the film firmly but gently with a cellulose sponge. The sponge should be wetted, then squeezed dry before using. Let the film dry in a place where there isn't any dust flying around. When dry (overnight) cut the film into convenient lengths and store in a clean envelope. Write on the envelope just what

negatives are contained there. Then you can easily locate them when you need them.

Cleanliness

With all darkroom work cleanliness is vitally important! Any spots, scratches, or dirt on a negative will show up in the contact print or enlargements. And if even a drop from one solution gets mixed up with another, the action of the contaminated one is unpredictable. So be sure to wash all bottles, tanks, or trays before and after they are used. Wash your hands after handling chemicals. Use a special bottle for each solution. Keep your hypo bottle only for hypo, for example, and mark it clearly. Do the same with the trays you use with contact or enlarging papers. Keep one only for developing, one for hypo, and don't mix them up.

When are your chemicals used up?

Every time you use your developer it is weakened. Therefore, after the first roll of film has been developed, the time of development for the following rolls must be increased somewhat. Each roll is developed a minute or so longer than the preceding one. The container your developer comes in will have instructions about just how much increase in time is needed. Another method is to keep the developer at the original degree of strength by adding a "replenisher." This is a special, separate solution. After each roll is developed you add a certain amount of replenisher to keep the developer at a constant strength.

Hypo also gets used up. There are instructions on the package indicating how many rolls (or sheets of photographic paper) it will fix before it is exhausted. If there is any doubt about the strength or cleanliness of a solution, most photographers won't take any chances and will throw it out and make a new batch.

CONTACT PRINTING

This is the process of sending light through the negative and onto a piece of photosensitive paper. This paper, like the film for your negatives, is also coated with an emulsion containing light-sensitive silver salts. After the paper has been exposed it is developed in a way that is very similar to the way you developed the negative. However, the paper is not nearly as light-sensitive as film, so that the entire process can be done under a special, dim, greenish-yellow light called a *safelight*.

The Equipment

1. THREE TRAYS. One for the developer, one for the stop-bath, one for the hypo. Plastic trays about 8″ by 10″ are available in any photography store.

2. TWO TONGS. These are for handling the paper in the trays. One is used for the developer tray, the other for the stop-bath and hypo trays. (You don't want to use your fingers and get one solution contaminated with another.)

3. A PLATE OF GLASS about 8″ by 10″. This is to hold the negative flat down on the contact paper. There are special printing frames made to hold negative and paper snugly together. But you can get by with just the glass.

4. A SMALL GOOSENECK LAMP, or something similar, with a 40-watt bulb. This is to provide the light that will shine through your negative onto the contact paper.

5. A SAFELIGHT. This looks like a small box or can. It has a weak bulb inside. One side or end contains a greenish-yellow filter. The filter allows only harmless, greenish light to pass through, which will not affect photographic paper. The safelight can be screwed into any light socket or small lamp.

EASTMAN KODAK COMPANY:
A safe-light.

6. BLOTTERS. These are for drying the finished prints. You can get a book of blotters into which the prints are placed, or a roll of blotting paper. If you just spread your prints out to dry on a table or shelf they will curl up so badly they will be useless.

7. CONTACT PAPER. There are various grades of photographic printing papers. They are numbered 1 through 4. Number 1 is for use with negatives that are very contrasty—very dense blacks and clear whites. Number 4 is for "flat" negatives that don't have much contrast. On a flat negative everything looks gray. Number 2 is for the average negative. Papers also come in glossy or nonglossy surfaces. Start with number 2-glossy, which should take care of the average situation. Paper also comes in different standard sizes up to 8″ by 10″. Choose a size which is suitable to your negative size. Remember that you can easily print several negatives at the same time if they are the same degree of darkness and contrast. You can also cut the paper into whatever size you want. If you are using a printing frame use a paper that will fit into it. (Remember that you can't open any package of photographic paper unless you are completely in the dark, except for the safelight.)

The Chemicals

1. DEVELOPER. This is not the same developer you used for your negatives. This is a developer for photographic *papers*. A common paper developer is called Dektol, and it should be mixed as directed on the package. When this solution is mixed as directed, you have what is called a "stock solution." This solution by itself is too powerful, so it is mixed with two parts of water. (One part stock solution, two parts water is the common proportion, but check with the instructions on the package.) The temperature of the solution is not as critical as with the developer used for the negatives. But it should still be approximately 68 degrees.

2. STOP-BATH OR WASH. This is the solution you use after the paper has been developed, and it can be the same solution you used for your negatives. The stop-bath serves

to stop the action of the developer. It is prepared as indicated on the container. It is best to use a stop-bath, but if you don't want to bother with another solution, you can get by using simply water in this tray. But the water should be changed occasionally.

3. Hypo or Fixer. This is exactly the same as the hypo used for your negatives. If you are processing a lot of negatives and doing a lot of printing it is a good idea to keep a separate bottle of hypo for your negatives and another for your prints.

How to Do It

1. Printing. Put the room lights out and your safe-light on. Place a piece of printing paper, emulsion side up, on a table top. (The emulsion side of the paper is the shiny side.) Place your negative on top of the paper, emulsion side down. (The emulsion side of the negative is the *dull* side.) The rule is "emulsion to emulsion." If the negative is the wrong way, everything will be reversed in the final print. Place the glass on top of negative and paper. Be sure it is holding everything down perfectly flat. If the negative is buckled you will get a fuzzy print. Place your gooseneck lamp a foot away from the paper. Try a three-second exposure to begin with. If you don't have a timer which can be set to ring at three seconds try counting, "one-and, two-and, three-and," slowly.

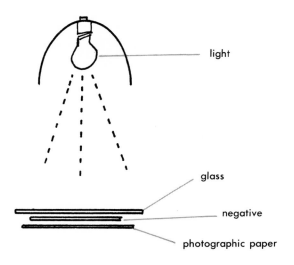

light

glass

negative

photographic paper

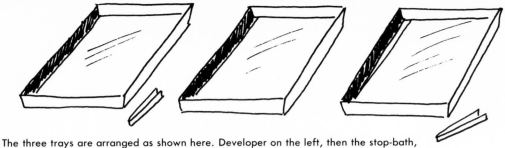

The three trays are arranged as shown here. Developer on the left, then the stop-bath, then hypo. One pair of tongs is used only with the developer, and another pair is used for the stop-bath and hypo.

2. DEVELOPING. Now pop the paper into the tray that has the developer. Keep stirring the paper, using tongs. In a few seconds you will see the picture begin to appear—the dark areas first. In about a minute the picture should be fully developed.

If you find that you have to jerk the paper out of the developer quickly because the print is getting too dark, it means that you have exposed the paper too long. Try it again with a shorter exposure, or move the lamp farther away.

If the print is too light, even if you leave it in the developer for a full one or two minutes, it means that your exposure was too short. Try again, exposing the paper for a longer time.

When you take the paper out of one solution, hold it up by a corner for a second or so, while the excess solution drips off. Then place in the next tray.

3. STOP-BATH. The print is left in this solution for about five seconds. This stops the action of the developer. Keep agitating the paper while it is in this tray.

4. FIXING. Leave the print in the hypo for about ten minutes, agitating it from time to time.

5. WASHING. Then put it in another tray or the sink and let fresh water wash over it for at least a half hour. If you have several prints washing at the same time, keep shifting them about so that they will all wash thoroughly.

6. DRYING. Finally, mop the prints with a sponge and place them between blotters or in a blotter roll. They will dry in a few hours. If the prints are not perfectly dry when you look at them, place them back in the blotters and give them more time.

ENLARGING

This is the most exciting part of darkroom work. Here you make the final, end product of the entire photographic process. The enlarging process is the same as contact printing, except that now the negative is not in contact with the photographic paper. The negative is *projected* onto the paper by means of the enlarger. This means that you can control the size of the print by adjusting the distance of the enlarger from the paper. The principle of the enlarger is exactly the same as that of a movie or slide projector; light is projected through a negative, focused by a lens, forming an image on your paper.

There are limits to how big an enlargement you can make. Detail is lost beyond a certain size and the grain of the negative becomes apparent. (The grain is the individual particles of the silver salts which remain on your processed negative. They are not apparent until the negative is enlarged quite a bit.) When you take pictures knowing that you will make big enlargements, it is wise to use a *fine grain* film such as Kodak Panatomic-X. This kind of film is slower than most of the other films, but can be greatly enlarged before the grain becomes objectionable.

The quality of your negative becomes apparent when you enlarge. If it is scratched or dirty or slightly out of focus, or overexposed or underexposed, you will find this out when you enlarge it. The bigger the enlargement you make the more obvious all the defects will be.

The Equipment

1. THE ENLARGER. This consists of the parts shown in the diagram below.

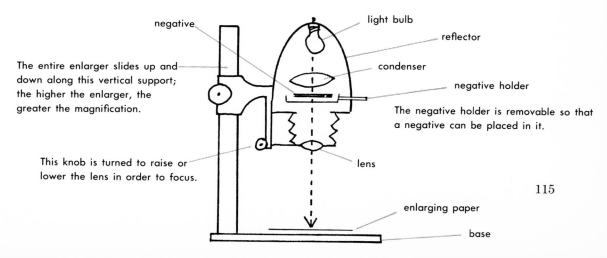

negative

light bulb

reflector

The entire enlarger slides up and down along this vertical support; the higher the enlarger, the greater the magnification.

condenser

negative holder

The negative holder is removable so that a negative can be placed in it.

This knob is turned to raise or lower the lens in order to focus.

lens

enlarging paper

base

115

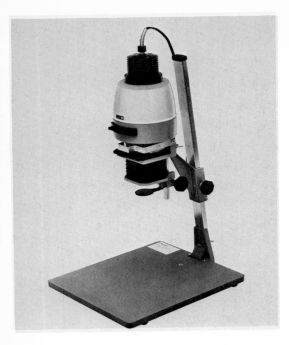

OMEGA. The wide metal bands on this easel are adjustable to any size up to 16 by 20 inches.

VIVITAR. This enlarger will take a negative size up to $2\frac{1}{4}$ by $2\frac{1}{4}$ inches. There are enlargers made for use with larger or smaller negatives.

2. THREE TRAYS, TWO TONGS, SAFELIGHT, BLOTTERS. These are the same as were used for contact printing.

3. AN EASEL. This is a device to hold your enlarging paper down flat while the enlarger is projecting the image onto it. There are two types. One is like a picture frame and the enlarging paper is slipped into it. It comes in various sizes which match the usual enlarging paper sizes: 4″ by 5″, 5″ by 7″ and 8″ by 10″. The other kind of easel is adjustable to any size or proportion you want. Both kinds will give you a white border around the enlargement.

4. ENLARGING PAPER. There is a wide variety of enlarging papers. You can get single weight, which is fairly thin, or double weight, which is much heavier. There are also different surfaces—some rough, some pebbled, some smooth. Camera stores have samples you can look at before deciding which you want. There are also different degrees of contrast, like the contact papers. Number 1 is for use with negatives which are very contrasty. Number 4, at the other extreme, is for negatives which are very uncontrasty, or flat. A number 2 paper is most suitable for the average negative.

The Chemicals

You can use the same paper developer, stop-bath, and fixer (hypo) that you used for contact printing.

How to Do It

Prepare your solutions in your three trays. Put on the safelight. Turn out the room lights. Put your negative in the negative carrier. Slip it into the enlarger. (The emulsion side, which is the dull side, is placed face down.) Place your easel under the enlarger and turn the enlarger light on. Raise or lower the enlarger until you get the size picture you want. Then focus the lens to get the sharpest possible image. The enlarger lens, just like the camera lens, has a diaphragm which is adjustable to let more or less light pass through. The usual practice is to open up the diaphragm to its maximum opening while you are focusing. Then close it down a step or two for maximum sharpness when the actual exposure is made. Now you're all set to go, but how long must the enlarger light be on in order to get the proper exposure? You find this out by trial and error, using a *test strip*.

The Test Strip

Take a piece of your enlarging paper and cut off a strip approximately 2″ by 5″. (Of course, you should only open the package of enlarging paper with room lights off and safelight on.) Place your test strip on the easel. Position it so that it is more or less in a main area of your picture. If you were doing a portrait, for example, you would put the test strip where the face is, rather than the background. Turn on the enlarger. Cover all but about an inch of the test strip with a piece of cardboard. (Hold the cardboard about a half-inch above the enlarging paper, so that the paper won't shift as you move the cardboard.) After the enlarger has been on for about five seconds shift

This test strip was exposed for 25, 20, 15, 10 and 5 seconds.

the cardboard so as to expose an additional inch of paper. Continue doing this at five-second intervals until the entire strip has been exposed.

Turn off the enlarger and develop, stop, and fix the strip. Now you can put on the room light and examine the strip and decide what is the correct exposure.

Once you know the correct exposure, you can proceed with the actual, full-size enlargement. While you are making the exposure, be careful not to jiggle the enlarger or the table on which it is placed. This would cause a blurred picture. The developing, rinsing, fixing, and washing is exactly the same as with the contact prints.

Your prints won't look very nice if they are buckled or curled up, so dry them carefully. The best way is to put them in a blotter roll, or between flat blotters with a heavy weight on top. Wipe them off with a sponge before putting them in the blotters, and give them plenty of time to dry.

The enlarging process not only allows you to make big prints, but lets you make all kinds of changes and adjustments which are not possible with contact prints. As shown below, you can easily eliminate unwanted parts of a picture. This is called "cropping." It can make a poor composition into a good one.

JACK ROSENTHAL. The print on the left shows the entire negative. The print on the right has been cropped.

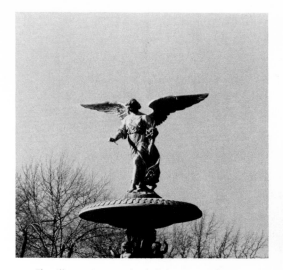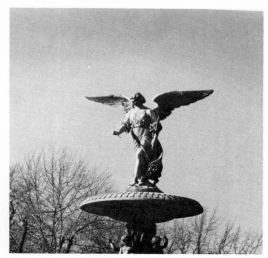

The illustration on the left is a straight print. The upper part of the other print has been burned in.

You can also darken an area of a print by what is called "burning in." This involves allowing more light to reach one part of the print than another part. A piece of cardboard with a 1-1/2"-diameter hole cut in it will be useful for this operation. "Dodging" is the opposite of burning in. You use your hand or a small cardboard disk to hold back light from particular areas. In both instances the light-blocking object is kept continually moving in order to avoid a hard line at the edge of the altered area. The enlarger can also be used for some rather unorthodox kinds of printing, as the illustrations on pages 98, 99 show.

Finished Prints and What to Do with Them

Small prints can be mounted in an album or the kind of booklet or folder described on page 53. But 5" by 7" or 8" by 10" prints look best if mounted on mat board or some stiff backing. You can get some kind of suitable mounting board in an art store. Several prints mounted like this and kept in a portfolio are very impressive. And when you want to hang one up it is a simple matter to slip it into a frame.

Attaching the print to its mount can be a bit of a problem. You should do some experimenting until you find the method you prefer. You might try library paste, sparingly applied. With this method it is important to place

the mounted print under a good, heavy weight until the paste has dried. Rubber cement is not very good because it is not permanent, and can be messy. The best and most professional method is to use "dry mounting tissue." This is a thin sheet of adhesive-impregnated paper available in camera shops. It looks like waxed paper. It is placed between the print and the mount, a piece of brown paper is placed temporarily on top of the print, then a hot iron is rubbed over all this.

Conclusion

A good photograph is determined by what is *behind* the camera as well as what is in front of it. In other words, the skill and imagination of the photographer are as important as interesting subject matter. With practice and by reading a few books, anyone can learn the technical part of photography. It may seem complicated at first, but it is not. What is more subtle and difficult is developing the "photographer's eye"—learning to look at something or somebody and seeing what kind of photograph it will make. This is what takes imagination, understanding of people, and experience with your camera. With time and practice, you will eventually develop the "photographer's eye," and then you'll be on the way to becoming a really good photographer.